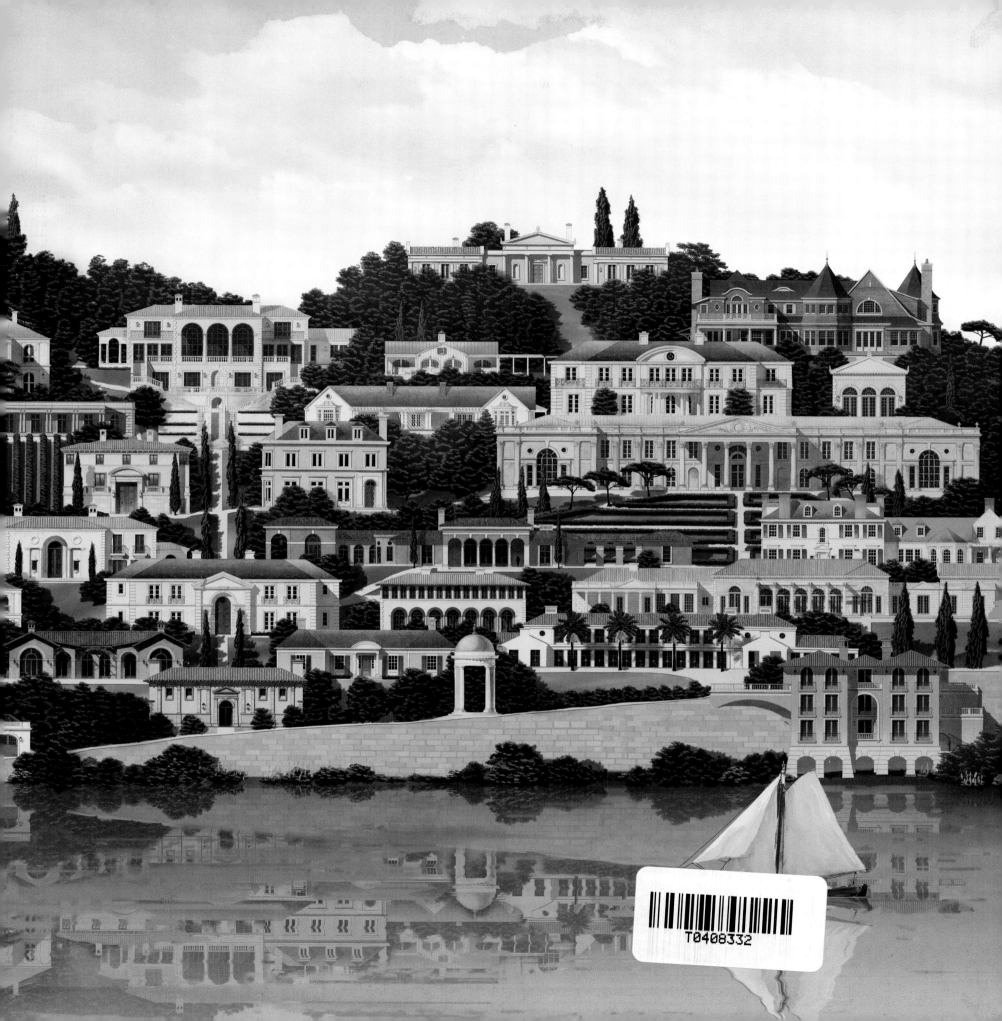

THE WATERCOLORS OF SKURMAN ARCHITECTS

THE WATERCOLORS OF SKURMAN ARCHITECTS

CLIVE ASLET

FOREWORD BY MICHAEL LYKOUDIS

TRIGLYPH
BOOKS

DEDICATION

Over the decades of our firm's work, we have been fortunate to welcome a number of summer interns from the School of Architecture at the University of Notre Dame. Some of these have gone on to become associates of the firm after their graduation. All of these students came to us with a detailed knowledge of the practice of architectural watercolor-wash rendering, and a capable hand, having been carefully trained at university.

During their internships, these students have practiced their skills with our guidance, rendering projects of ours which were on the boards, under construction, or completed. This book is a collection of some of the best of our work together with these students. Neither this book, nor our work as a firm would be possible without the invaluable education provided to students of architecture at the University of Notre Dame.

Andrew Skurman

ENDPAPER: *A Capriccio of the Work of Skurman Architects*
by Alexander Preudhomme.

CONTENTS

Foreword by Michael Lykoudis 7

Introduction 8

URBAN HOMES 13

A French Hôtel Particulier 14

A Georgian City House 15

An Addition to the
Lewis G. Morris House 16

An Italian Palazzo 17

A Georgian Townhouse 18

Entrance to
a Georgian Townhouse 19

A Townhouse in Warsaw 20

Section Through
a French Townhouse 21

A French City House 22

A Southern-French
Hôtel Particulier 23

The Salon Doré
at the Legion of Honor
in San Francisco 24

SUBURBAN VILLAS 27

A Southern-French
Renaissance Château 28

A Louis XVI Pavillon 29

An Indo-Doric Palace 30

A Classical Greek House 31

A Georgian Cottage 32

A French Pavillon 33

An Etruscan Villa 34

An Early-American
Country House 35

A Florentine Villa 36

A Spanish Colonial Villa 37

An English Cottage 38

A Hôtel Particulier in India 39

A Palladian Villa 40

A Pavilion After de L'Orme at
an American Georgian House 41

Section Through the Entrance
Hall of a Georgian Penthouse
Apartment 42

A Monopteral Temple at
the Resort at Pelican Hill 43

COUNTRY ESTATES 45

An Anglo-Norman
Country House 46

A Tuscan Villa 47

A Terraced Spanish Villa 48

An Italian Lakeside Villa 49

A Shingle-Style Cottage 50

An Equestrian Estate 51

A Norman Manoir 52

A Palladian Palace 53

An English Country Estate 54

An American Country Estate 56

A French Palace 57

PHOTOGRAPHIC RECORD 59

Project Credits 108

Acknowledgments 111

FOREWORD

BY MICHAEL LYKOUDIS

Professor and Dean Emeritus of Architecture at the University of Notre Dame

The Watercolors of Skurman Architects is a beautiful book with a novel approach to displaying a collection of elevational drawings that have come out of the office over the past three decades. Each drawing is a separate plate so that they can be arranged in any number of ways and analyzed and compared by the reader. What makes these drawings stand out, aside from the format, is that they are remarkable in their clarity to convey the many levels of design while being striking objects in and of themselves.

As architects increasingly rely on computers to design and convey their ideas, the results often seem static and lifeless. Andrew Skurman's work is designed first by hand and then is transferred to computers to take advantage of the efficiency of their storage and retrieval abilities. What sets his work apart from the computer drawings of other firms, is that the knowledge gained through hand drawings and watercolor presentation methods is then applied to the computer.

Most architects learned to design through drawings. The two-dimensional drawing clearly conveys the overall concept, order, and composition of a building. Typically, traditional architecture schools teach design through the use of plans, elevations, and sections. Those kinds of drawings are essential to design, document, and analyze a building. While some architects have designed in perspective or in situ, the two-dimensional drawing remains one of the clearest forms of codifying and illustrating the ordering systems that define a building.

As the student evolves in his or her thinking, they will begin to incorporate into their design process the aspects of architecture that breathe life into a project: such as materials, textures and colors, the play of light etc. Clarifying the elements and principles of a building design through orthographic drawing focuses the endless possibilities of the empty page for the student by limiting the representation of their ideas to two dimensions.

Like a sheet of music, an elevation illustrates the rhythms, pauses or rests of a design and the proportional relationships of openings against the blank canvas of the walls. Elevations also illustrate how the architectural elements are grouped horizontally and vertically, and how they modulate the scale of a building and the reading of its composition. In plan, drawings allow us to see the parti, or central organizing concept of the building, along with the processional sequences, layering, and registration of rooms through their openings and other elements. Drawings show us the intentions of the architect unfiltered through perspectives, materiality and other aspects of the real purpose of architecture, which is to build buildings. The drawing can show us the building before its manifestation as a physical object.

From that perspective, Andrew Skurman's drawings are didactic. They illustrate the compositional intention and thinking of the architect in the purest formal manner possible without the encumbrance of the finished product. With respect to walls, openings, and roofs, they reveal the disposition of the building through the rhythms established by windows, doors, colonnades, and arcades and all the other architectural elements that contribute to its character.

The Watercolors of Skurman Architects begins with a capriccio which presents much of the firm's work as part of an imaginary city. The city is complete with public buildings such as palaces, villas and stadia represented through the high classical character, and more modest domestic buildings represented by their more vernacular approach to composition and materials. The city's relationship to nature is also celebrated with a lake in the foreground and a forested hill in the background, punctuated with villas at the top. The inclusion of these elements highlights the relationship between nature and the classical.

The book's pages that follow illustrate the various buildings and their typology through their position in the spectrum of vernacular to monumental architecture. Seen side by side, in the case of An American Country Estate and A Palladian Palace, the viewer can acknowledge the continuities between the vernacular and the monumental, as well as the differences. Through the scale and rhythm of each elevation, one can read the relatively public or private nature of a given building.

We would be remiss if we did not acknowledge the importance of the large house architects to American architecture. Since the eighteenth century, the large house has been where American classicism has found its place, through invention and innovation. From Mount Vernon and Monticello to the large Newport houses of the nineteenth and early-twentieth century, the large house has provided an opportunity for young architects to learn and to develop through classicism's inexhaustible supply of inspiration, innovation, and invention.

Andrew Skurman's recognition of our responsibility to keep the classical tradition alive through innovation is evidenced throughout the drawings of this book which have been beautifully executed by his office. These drawings show the inventive and pedagogical bearing that he brings to his work, and the role that work is playing in the long American tradition of the big house. That Andrew sees himself as a teacher through his practice only adds to the importance and urgency of this book as we navigate between tradition and the ever-present modernity of each generation.

INTRODUCTION

This is a book about architectural drawings. It is designed in an unusual way: some of the drawings that have been reproduced can be taken out of the book and unfolded for close study, or so that they can be put on a wall. Drawing is the essence of architecture. Through it the architect can show his conception in its purest form before the inevitable adjustments and compromises have been made in order to realize the building. Andrew Skurman has been drawing all his life. The control of the pencil by hand and eye remain an essential tool of his practice, Skurman Architects. There is nothing he enjoys more than to sit at his drawing board designing houses, using the traditional tools. The first plans of a project are always drawn by hand.

Andy, as everyone calls him, knew that he wanted to be an architect from the age of 12. There were architects in his family. His father was an engineer who worked on elevators. As a boy, Skurman senior had walked from Vienna to Amsterdam with his friend to escape Nazi persecution. Having crossed the Atlantic, he married Andy's mother, whose father had an elevator business; he was a brilliant man with many patents to his name. At high school in New York, the young Andy excelled at mechanical drawing and industrial arts— every assignment was completed to perfection. It was a compliment that his teachers thought he should become an industrial arts teacher himself. He had always won praise for his drawing. At the age of 14, when he refused to go to summer camp with his brothers, his parents, despairing of what to do with him, suggested he should work in his grandfather's office. He was put to work as a draughtsman and loved it.

Architecture school beckoned and his choice was the Cooper Union School of Art and Architecture. Here, he would have an excellent education under the inspiring John Hedjuk. While dedicated to the primacy of the grid, in the manner of Mies van der Rohe, Hedjuk also felt that ideas were as important as built architecture, and that the latter could evoke alternative worlds. Architecture students at this time uniformly worshiped Le Corbusier, who appeared capable of reshaping the entire world to fit the conditions of the Machine Age—while also expressing an unexpected poetry in his later works, such as the chapel at Ronchamp in eastern France. Andy's first job was in the office of the great I. M. Pei, architect of the East Wing of the National Gallery of Art in Washington, D.C., and (later) the Louvre Pyramid in Paris. He was another who believed in "an architecture of ideas." While at I. M. Pei and Partners, Andy worked on skyscrapers and museum buildings, helping to design the Asian gallery of the Boston Museum of Fine Arts. "I was born an architect," says Andy. "I took to it straight away."

With Pei, Andy "learnt integrity." He liked the office. But he had to resign from it when his first wife had a baby and felt that New York City was too grittily urban an environment in which to raise a young child. Where would they go? It was

an open question, as far as Andy was concerned, and he was happy to let her settle on San Francisco. The big Chicago practice of Skimore, Owings & Merrill had a studio there, opened after the Second World War to design buildings for the U.S. Navy; it had recently built the Louise M. Davies Symphony Hall in the city. Andy made the move in 1981 and did not regret it. He has stayed in San Francisco ever since, fortunate that the economy has boomed thanks to Silicon Valley. "At SOM I learned to be in charge of a large commercial project and interact with clients." In 1987, he was tempted by an offer from Gensler and Associates, one of the biggest architectural firms in the world; there he managed a design studio. But he did not warm to the culture of the organisation. While at SOM, he had seen a Chicago industrialist come to the practice for a large house on the bay in Belvedere, San Francisco. Although his previous professional life had been spent designing commercial architecture, this made him realize that there was a market for high-end residential work, which could be enjoyable as well as rewarding. He also had something of a spiritual awakening. There was room for an architect who worked in the classical style. In 1992, aged 39, he left Gensler to open his own office.

Until that time, Andy had only designed in the modernist idiom of the practices that employed him. Classicism had not featured on his curriculum at the Cooper Union nor in his subsequent work. But now he found that "it was me"—the order and symmetry of classicism spoke deeply to his inner self. "The symmetry of rooms is what makes me happy," he says. "I find it calm and relaxing." He discovered also that he had a reservoir of knowledge that he had absorbed over time without having previously had an occasion to draw on it. This stemmed from a friendship he had made during his Cooper Union years, after lending his attic to a French couple who needed somewhere to stay. When they returned to Paris, Andy was invited to visit them. He made many trips during which he roamed the city, marvelling at its streets and observing the details of its architecture. This he internalised to such an extent that he could quarry it, as though by instinct, in his later work. His connection with the city has been reinforced by marriage since his second wife, Francoise, is French. The Skurmans now have an apartment in Paris and an old farmhouse in Normandy.

The transition from salary man to independent architect required a degree of courage. Andy was now on his own supporting himself, his wife, and his son on his credit cards, working from the family apartment where space was so tight that he slept beneath the drafting boards. As the son of immigrants, he had a fierce desire to succeed, born of the knowledge that there was no turning back. The fledgling firm's first commission was to design some guard houses and other practical buildings for a large residential development. They may have been small but they were enough to launch the practice. Before long, Andy realized

that while classical decoration was generally unfamiliar to other architects it was much used by interior designers. This lead to a collaboration with Tucker & Marks which has lasted three decades. It has been said that Suzanne Tucker and Andy Skurman are the Ginger Rogers and Fred Astaire of their world.

However, Andy still had to learn the rules of classical architecture. To do so, he followed the example of countless other architects down the centuries and turned to the treatises and pattern books published by the masters of the past. Andrea Palladio's *I Quattro Libri dell'Architettura*, published in the sixteenth century, was a golden resource. The villas on the Veneto that Palladio illustrates are often of a suitable scale and simplicity for American life in the twenty-first century. He began to assemble the library that is now an essential reference point for the office, amounting to hundreds of volumes. Compendia of architectural detail, such as *Mouldings and Turned Woodwork of the 16th, 17th and 18th Centuries* by Tunstall Small and Christopher Woodbridge, and *Three Centuries of Architectural Craftsmanship* edited by Colin Amery are conspicuously well-thumbed. It was timely that, in 1990, shortly before Andy went solo, the British Classical Revivalist Robert Adam should have brought out *Classical Architecture: A Complete Handbook*, a guide to the language of classicism somewhat in the format of an eighteenth-century pattern book. Andy was helped by the strength of his visual memory, combined with the memories of Paris that "were engraved in my mind". He echoes the British classicist Quinlan Terry in saying "I never make anything up," because classicism relies on precedent: one of its strengths is that over two and a half thousand years architects working within the tradition will invariably have encountered similar problems to those facing the contemporary architect today.

Studying the plan of Hadrian's Villa at Tivoli, outside Rome, provides inspiration for the use of small circular spaces that can serve as hinge points, so that a change in axis goes unperceived. While Hadrian's Villa was built in the early-second century AD over a vast area, largely of garden, its lessons are just as applicable to an apartment in today's San Francisco. Of course, building techniques have moved on since the Roman period, when little thought was given to protecting against earthquakes (although some forms of traditional construction are more flexible and therefore fared better than the more rigid methods of later times). In the twenty-first century, classicists can take advantage of a range of computer-aided devices, which can help in detailing flamboyant curves which would take a long time to draw by hand. Laser-cutting means that complex patterns can be easily created and reproduced: John Ruskin, the nineteenth-century sage who inspired the Arts and Crafts movement, might not have approved but there is little difference to the eye between a laser-cut grille and one made at greater expense by a craftsman. Fortunately, though, the San Francisco area has two qualities which align it

with the classical world of Ancient Greece and Rome. The first is that many excellent craftsmen live there, so that it is rarely necessary for Andy to look beyond the boundaries of the State of California to find workmanship of the highest level. The second is the climate, so like that of the Mediterranean where classicism was born. Classical mouldings look best when seen in bright sunlight which casts shadows. The skies of California often oblige.

What are the salient qualities of Skurman Architects' work? We have already seen the first—namely, that drawing is paramount. Architects think differently with a pencil in their hand. These days, the first recourse of many in the profession is to the computer, and it can be a powerful tool which aids the process of design. But hand drawing tends to create a freer, more plastic and more coherent result. Besides, it is more pleasurable—and some of that joy communicates itself to the finished building.

Secondly, work at Skurman Architects is seen as a collaborative process. While designs usually begin on Andy's drawing board, they are developed and realized by the team, who all speak the same architectural language. The studio directors, Ed Watkins and Pierre Guettier, share the laurels equally with the principal of the firm. Pierre has been with Skurman Architects for 20 years and like Andy, went to Cooper Union. Having been partly brought up in France and now retaining French nationality alongside his American citizenship, he has a deep knowledge of French cities, which he has studied as part of the natural course of his life. But the strength of the practice does not only come from the quality of the individuals at the top. As Pierre puts it, "the beauty of our firm is that we have such a great staff. Everyone is of top quality so we all rely on each other to do different tasks. There is a spirit of collaboration; we work extremely well with each other." Ed Watkins studied at New York Institute of Technology, whose teaching remains very modernist; afterwards, though, he worked for Donald Rattner, then of Ferguson, Shamamian & Rattner, before joining the grandly classical firm of the New York architect and designer David Easton. When Andy flew Ed out to interview for his first position in the firm, as a welcome to California, Andy mentioned that he might remove his tie.

"I like high end residential work, which involves close interaction with the client," says Ed. "What are they looking for? How will the spaces be used? There is the joy of working with old buildings too."

Thirdly, the stylistic repertoire is unusually wide, embracing not just one form of classical architecture but many. You need only glance at Alexander Preudhomme's *A Capriccio of the Work of Skurman Architects* to see the variety. This Capriccio was prepared in anticipation of the Arthur Ross Award in Architecture, bestowed upon the firm in 2020 by the Institute of Classical Architecture and Art. The award is recognition of achievement over the entire lifetime of the firm, and it is given by the premier advocacy organization for classical

architecture in the U.S. This demonstrates the extent to which the firm has found success across this broad spectrum of architectural expression.

The Early-American Country House evokes colonial Williamsburg, with its clapboard walls, shutters and generous porch. Everything on the property conforms to the same idea, as a result of which it feels restful. Florence, Tuscany, Greece, English Tudor and the shingle style of America's Gilded Age provide some of the other sources. The Terraced Spanish Villa looks as though it has been built on a Mediterranean hillside overlooking the sea. The Italian Lakeside Villa might have come from the shores of Lake Garda. France is a constant inspiration. The garden gates of the Élysée Palace, built in 1772 and now the official residence of the President of France, gave the theme for the gilded gateway of the French Palace. A commission to help restore the neoclassical Salon Doré from the Hôtel de la Trémoille in Paris, on display since 1959 in San Francisco's Legion of Honor Museum, gave Skurman Architects the opportunity to work on a grand interior from the reign of Louis XVI. The work involved designing a new ceiling, detailing new windows, and installing an eighteenth-century parquet de Versailles floor.

Fourthly, Skurman Architects specializes in polite architecture which does not intend to shock or outrage, but respects the other buildings on a street. The Georgian Townhouse illustrated here is a case in point. Sandwiched between a strikingly modern house on one side and a traditional one on the other, the insertion had to be strong enough to form a link between the two contrasting neighbours—while not asserting its own personality so far as to add a discordant note. The right balance is achieved by a giant portico at second floor level which rises up through the third story; but instead of being crowned by a pediment, which would have been too assertive on this position, Ed Watkins took inspiration from Charleston, South Carolina, where columns often support a trellis or pergola. This has the advantage of casting the dappled shadows shown in the elevation drawing. Among the many details designed by the firm are the lanterns that light the "piazza" (as the verandah would be called in Charleston): they are hung from chains and secured by other chains to stop them swinging violently in high winds.

For the addition to the Lewis G. Morris House in New York, Skurman Architects proposed a structure in the same material—red brick—as the Beaux-Arts House designed by Ernest Flagg in 1913. But the gable, projecting window bays, and shutters make it sufficiently different for passers-by not to confuse the two periods of work. This provides a more harmonious solution than a starkly modern addition might have done.

Fifthly, Skurman Architects is as happy working in the city as in the countryside. Both contexts have their challenges, but the city can be a particularly tough environment. The Italian Palazzo is on a high point of San Francisco, grappled to a bluff of rock. Everything on the outside of this originally 1920s house was renewed, and a new entrance for cars was created. Inside, Andy and Pierre created a swooping staircase and a dense plan using light that enters via shafts through the attic. Stone for the voluptuous stair stringers was carefully computer modelled, and then fashioned out of large bocks by a combination of human toil and advanced robotics. The heavy pocket doors are so well crafted that they can be moved with a fingertip; when they retreat into the pockets, an outer bead moulding gives the impression of a miraculously close fit.

Plaster vaults are a particular feature. "I love vaults," says Andy, "we do some of the most beautiful vaults being built today." Apartments can be even more complex for the architect. Invariably the internal space is gutted, except for the structural steels, and the plan completely reworked, as though on a blank sheet of paper. Magically this produces not only a more elegant layout, perhaps with rooms paneled with boiseries, but also more usable square feet than had previously existed.

Sixthly, Skurman Architects has worked not only in California but also Australia, India, China, Israel, Poland, Mexico, France, and Tahiti. So for a relatively small office the practice has a global reach. Some of these commissions have come at the recommendation of happy clients, others the result of magazine publications, or press from awards and recent projects. "Working abroad, I imagine myself as Louis Kahn in Dhaka or Le Corbusier in Chandigarh. Each project affords a wonderful experience." remarks Andy. The experience, one suspects, is as wonderful for the client as for the architect. This, surely, has been the secret of Skurman Architects' success.

A BRIEF HISTORY OF ARCHITECTURAL DRAWING

In the Middle Ages, God, as the architect of the universe, was depicted with a compass in his hand: the Bible records that he gave plans to Noah for the Ark. This would suggest that the practice of architectural drawing is very old. Confirmation comes from the ancient kingdom of Lavash in southern Mesopotamia, where a ruler called Gudea is known to history through his work rebuilding the temples and walls of the city of Lagash, which had suffered through warfare. On a headless, diorite statue of Gudea (c.2130 BC), a well-defined floor-plan of the shrine of Nigirsu is carved on the statue's lap. Glyphs on the statue give an account of the construction of the temple-shrine and include a list of materials used and their sources.

The Ancient Egyptians drew floor plans and elevations on papyrus, a paper-like substance made from the pith of the *Cyperus papyrus* plant. Examples include sectional drawings at the Temple of Isis at Philae, Egypt (c.100 BC) and a huge papyrus sheet (c.1350 BC)—the tallest sheet known to exist—from the site of Gurob in the Al-Fayyum region of Egypt which has plans, elevations and sections; it is thought to have been used as a tool for the builders of the site. A Babylonian clay tablet depicts in plan the Palace of Nur Adad (c.1865 BC). When the site it depicts was excavated in the 1930s, historians were able to clarify the relative accuracy of the drawing. The National Museum in Perugia, Italy, contains a funerary monument from the first century AD on which the plan of a tomb complex has been incised.

These are just some examples of architectural drawing as it existed in the Ancient World. The Chinese also knew about it. But more than half a millennium after the Sack of Rome in 410 and the collapse of the Roman Empire in the West, no architectural drawing has come down to us. Perhaps the art was lost. The so-called Dark Ages live up to their now academically unfashionable name. In the Middle Ages, master masons used drawing in the construction of cathedrals and great churches. Villiard de Honnecourt, a thirteenth-century artist from north France, is known only through a "sketchbook" (really a kind of album) which exists in the Bibliothèque nationale in Paris. This includes a depiction of the apse at Reims Cathedral, thought to be the earliest rendering of elevations of curved or polygonal spaces. Plans from 1150 can be found in the archives of Canterbury Cathedral, which set up the designs for the water circulation system. Towards the end of the medieval period, the designers of buildings (architects, as they would later be known) began to diverge from the masons and carpenters with whom they had previously been identified. Now less hands-on, it was more necessary than ever for detailed drawings and documentation to be available and be robust enough to be carted around site. Visual aids and verbal instructions were no longer enough.

The Renaissance period of the fifteenth to seventeenth centuries saw a growing number of architectural prints being distributed across the continent. Detailed studies of ancient buildings such as those in Italy were recorded by the likes of Andrea Palladio (1509–1580). Development of the perspective drawing in Italy gave architects, for the first time, the ability to give clients and academics naturalistic representations of buildings. Time and place could, at last, be expressed. The invention of the printing press aided the spread of Palladio's work: drawing could be reproduced and disseminated with relative ease. This enabled ideas to be transmitted beyond the immediate area of an architect's work. By 1800, the advance of building technology created new and impressive forms of civic architecture, which were conveyed to a wide audience in spectacular perspectives. As Sir John Soane told pupils during his Royal

Academy lectures, each of them "must be familiar with the use of Pencil and must not be satisfied with Geometrical delineations, for the real effect of Composition can only be correctly shown by Perspective representations. The student must therefore be fully acquainted with the theory and practice of Perspective, and be able to sketch his ideas with facility and correctness."

The establishment of English paper mills made paper cheaper and had the added bonus of production of a greater variety of paper-sizes. This, in turn, led to more and more drawings being produced, as is evident from the existence of innumerable sketch-drawings that can track the gradual refinement of a design. Increasingly "record drawings" were kept on file in the office. By 1900 the ready availability of books and other printed representation of historic architecture provided a rich architectural resource. This was fully exploited by the architects of the École des Beaux-Arts in Paris, the mecca for ambitious American architects as well as Frenchmen, in which drawing was an essential discipline.

Today, computer technology rules many architectural offices, often at the cost of the long-standing and elegant skill of hand-drawing. Skurman Architects is one of the few practices to combine the ancient skills of hand-drawing with the speed and other benefits of computer-aided design and large-format printers. Whilst a carefully hand-drawn piece is considered a work of art and treasured by architect or client, the myriad of computer-drawings printed to be refined and reprinted repeatedly hold much less value and are often consigned to the bin—the final set of drawings only needing to be stored digitally after construction is complete.

Recently, the internet has been flooded with AI-produced renderings, which blur the lines between reality and perceived beauty. Computers can digitally recreate hyper-modern structures as classical monuments within minutes. While technologically dazzling, such feats are nothing more than a gimmick. Only a living individual can understand the complex, emotional requirements of other human beings, which are met by great architecture. Great architecture in turn depends on great drawings. Like the classical tradition, which flows from the world of Ancient Greece and Rome, drawing has evolved over many centuries in response to human needs. Gudea of Lagash understood how it could communicate three dimensional ideas in the third millennium BC; for masters of the art, its power remains undimmed.

URBAN HOMES

Skurman Architects is a San Francisco practice, based on Sacramento Street. There is a pilaster of Raphaelesque decoration next to the plate glass window of the old shop front behind which the practice works; along with the many models on view inside the office, it is a statement of values, declaring the Skurman commitment to a wide cultural range of reference. This is only to be expected of a firm which also boasts an address in Paris, France. The projects shown in the following watercolors are sophisticated and urbane. Many are in San Francisco itself.

The history of San Francisco is well known: most of the original city was destroyed by the earthquake and fire of 1906. The city grid had been established, however, and it was repopulated with buildings, often from the 1920s. For Skurman Architects, the urban fabric that now exists on the famously vertiginous hills, their heights offering prized views of the Golden Gate Bridge, is glorious in the opportunities it presents and challenging in the complexities involved in almost any project. Setting is all important. The practice believes in neighbourliness: it wants to create buildings that harmonise, as far as possible, with those to either side. Fortunately, the firm is not doctrinaire about the style it works in; the ethos is to do all things and do them well. On top of everything, antipathy to development "has led to the strictest set of planning guidelines in the U.S.," according to one California architect.

When restoring—or reinventing—existing architecture, the standard of earthquake protection will need to be upgraded; this can be a major exercise in civil engineering. Cars need to be considered. If the space to store them is provided underground, that will require excavation. Remodelling an apartment will probably involve the removal of all the pre-existing walls, decoration, and kitchen and bathroom fittings, so that only structural steel columns are left. Despite these dramatic interventions, the result of any Skurman Architects project will look calm and gracious, as though what may be completely new spaces had been there all the time.

These qualities—calmness and graciousness—are expressed in the watercolors that follow, in the style of Beaux-Arts elevations. Readers will have to use their own imagination, aided by the photographs shown later in the book, when picturing the completed works. Fabulous entrance canopies; ferronnerie (the English word ironwork barely does it justice) in the manner of eighteenth-century France; the finest paneling that may be old or new; parquetry floors; plaster cornices and vaults; sweeping staircases—for Skurman Architects, these are all part of the stock-in-trade. Then comes what Andrew Skurman calls the box of tricks: the little sleights of hand which make a window look as if it reaches all the way to the ceiling whereas it really stops a yard short of it, or which funnel daylight through a shaft in the attic to brighten an internal space.

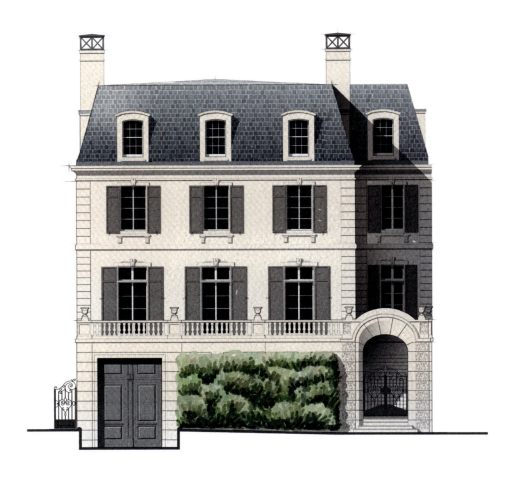

A French Hôtel Particulier

This beautiful city dwelling in the French style recalls the most stately homes in Paris, which are called hôtels particuliers. While undertaking a complete interior renovation, Skurman Architects carefully preserved and restored the exterior detailing, with a few subtle additions. A new stair along with a new Parisian-style garage door grace the street elevation. A new dependency featuring treillage detailing was added in the rear yard. Providing completely new interior architecture, the team maintained a strong French presence within the house, installing an entire antique-boiserie dining room salvaged from a demolished château. This room was secured at Galerie Steinitz in Paris by Suzanne Tucker of Tucker & Marks.

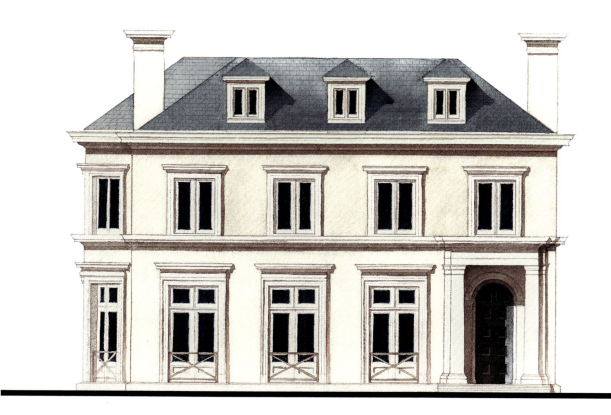

A GEORGIAN CITY HOUSE

This dignified city house in the Georgian style is the result of a rare opportunity to construct an entirely new home on a generous urban lot. The surrounding neighborhood is a unique historical district, and nearby the houses were built more than a century ago. Therefore, while newly conceived, the context of this project demanded an authentic expression of historical precedent. Skurman Architects made their design as a polite and quiet neighbor to its dignified context.

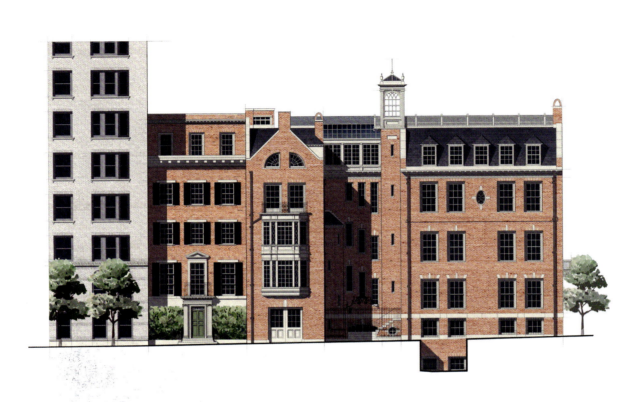

An Addition to the Lewis G. Morris House

Ernest Flagg designed the Lewis G. Morris House at 100 E 85th St. in Manhattan for Morris and his wife Alletta Bailey in 1914. Morris was a financier and a descendent of Gouverneur Morris, who was a signatory to the U.S. Constitution. Not five years after the house was completed, Morris's investment firm went under. However the family retained ownership of the house because it was listed as collateral for a loan Bailey made to her husband's firm. The original design shows clear English and American influences, and features distinctive asymmetrical elements such as descending windows along a staircase. The house is now owned by a foundation—as is the tenement building directly adjacent to it along 85th St. In preparation for a potential sale of both properties, Skurman Architects were approached by the foundation. They provided a speculative design for the renovation of the tenement building in a similar style to the Morris House next door. American historic preservation regulations prevented them from making the renovated building appear fully part of the original, but they employed the Georgian design language and complimentary articulations in order to join the properties thematically.

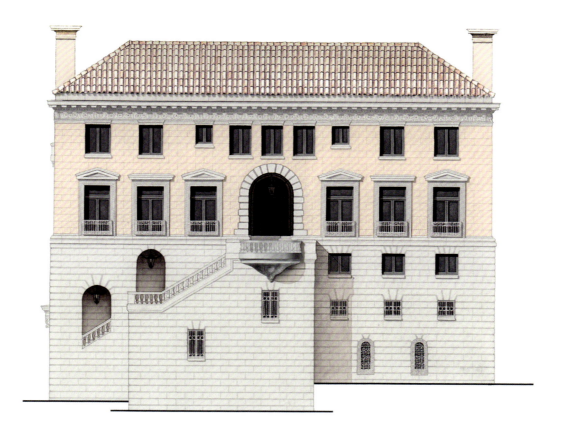

An Italian Palazzo

This grand and beautiful home in the city stood in its nearly original form from 80 years ago. The need to build a new seismically resilient structure within the walls provided the opportunity for a completely new interior, and Skurman Architects' renovation started with a blank sheet of vellum. The palazzo's striking exterior was painstakingly recreated out of historical consideration. Outside of the footprint of the original structure, a new, skylit swimming pool was added beneath the garden. The new marble staircase is the centerpiece of the interior architecture. It was realized following years of planning, and design coordinated between the Skurman Architects office and stonemasons, both nearby and in Italy.

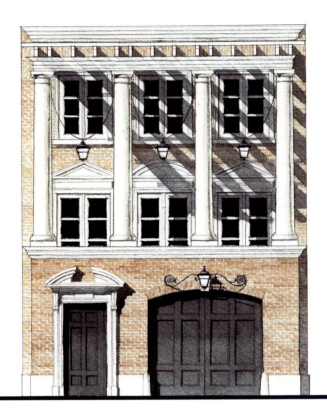

A Georgian Townhouse

Skurman Architects were honored to receive the commission for this new house, overlooking a large city park. As with any urban project, they wanted to place their design comfortably within its context on the street, but that context was peculiar. To the left of the proposed lot was a Georgian-style apartment building, but on its right was a flashy, aluminum-clad postmodern house with a heavy vertical element directly adjacent to the project property. In the classical language, the quintessential heavy, vertical element is the column, and so the architects set out searching for Georgian precedents featuring a colossal order at the front of an urban house. Among other inspirations, they found The Roper House in Charleston, South Carolina. The Roper House is a particular example of the single house type, common throughout historical Charleston. Once the idea had been transported to the West Coast, the typical loggia was rotated from the side to the front of the structure, so that it faces south toward the park. A pergola replaces the usual solid roof over the loggia, supported by a monumental Doric order.

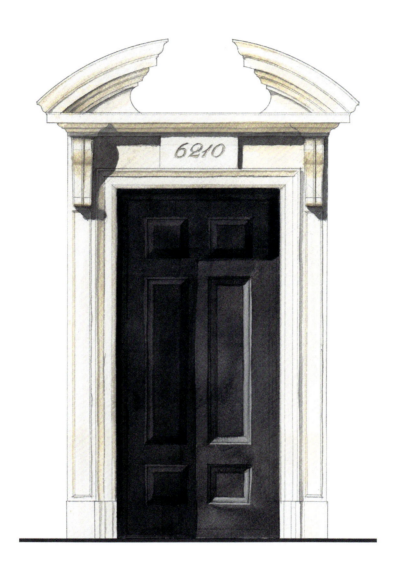

Entrance to a Georgian Townhouse

"God is in the details." This design for a doorcase provides a dignified and imposing entrance to a home. The broken, segmental pediment is supported on large brackets placed at the top of simplified pilasters. Above the handsomely paneled door is a tablet bearing the property's street number—an elegant solution to a common problem.

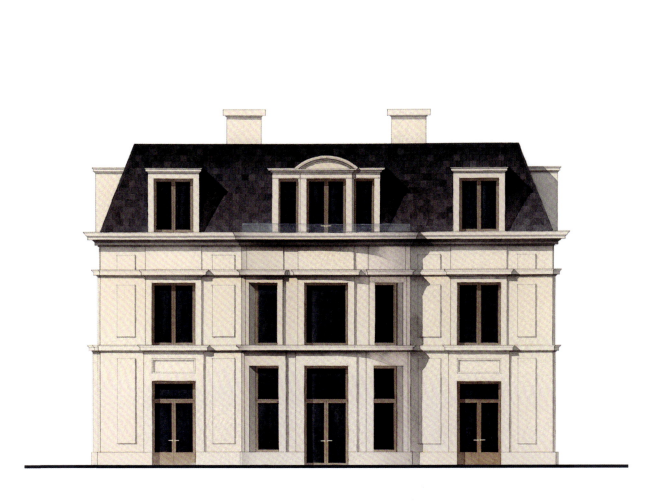

A Townhouse In Warsaw

This proposed design for a house in the Polish capital city faces a large urban park. To enjoy views of the park, the house has plenty of large windows. French influence can be seen in the mansard roof and details such as the segmental pediment atop the central dormer. The façade is articulated by repeated vertical bays of flat panels along the exterior, evoking columns. However, as with the windows and other detailing, these are a simplified suggestion of a classical order.

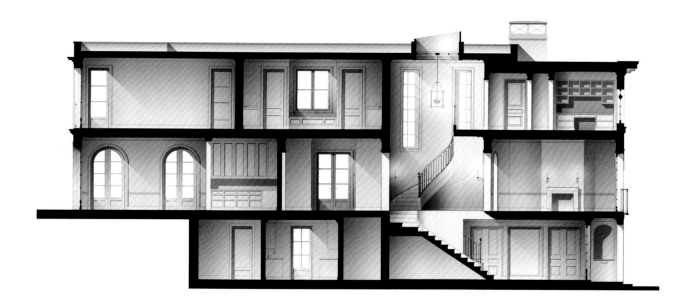

SECTION THROUGH A FRENCH TOWNHOUSE

This elegant residence is a newly-constructed home, except for the historical façade which was carefully preserved. From the façade Skurman Architects were inspired by the arched windows on the second level to create a true piano nobile, which is a formal European first floor occurring on the level above the street. They established a series of repeated openings on that level that bring the shape of the arched windows on the façade all the way through to the garden. Extending from the piano nobile to the top floor is a centrally located double height stair: a rare feature in a townhouse that recalls the work of Sir John Soane.

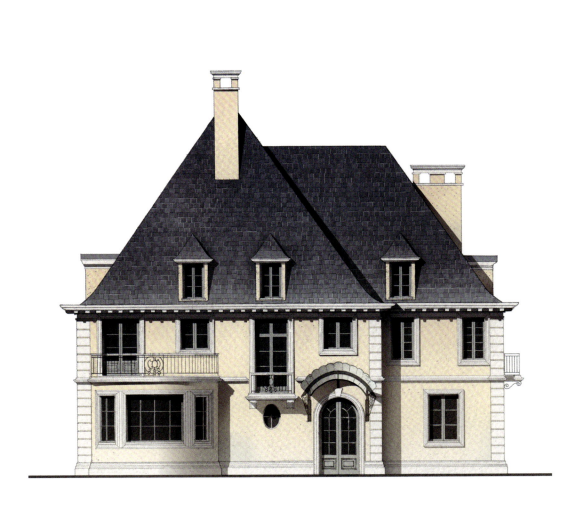

A French City House

As with many houses in San Francisco, this generous property in a notable, historic district already featured a few hints of French character. Skurman Architects were asked to renovate the house to bring out that character and to add authenticity to the detailing. The house now features a steep slate roof, corner quoining, and a glass marquise over the arched entrance doors. It is urban in actual context, but its architectural heritage is a mix of Parisian and more rural French styles.

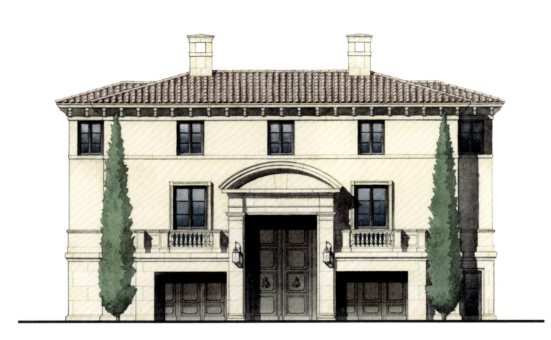

A Southern-French Hôtel Particulier

Skurman Architects oversaw the renovation and completion of this rare, urban parcel that extends through the block from street to street. Previously, the entrance faced the northern of the two streets, which was elevated significantly below first floor level. This required an extensive sequence of outdoor stairs as part of the previous entrance. The new entrance to the property is through an elegant gatehouse with a porte-cochère on the much higher level of the rear street. Arriving at the property, one now enters at the porte-cochère, walks across a new inner courtyard, and proceeds up a short flight of stairs into the main house. As the original house had never been finished, no interior architecture existed when Skurman took on the project. As well as completing the internal arrangements, they added an elevator and a roof deck. The detailing of the existing house was distinctly southern French, and this was respected by the new work.

THE SALON DORÉ AT THE LEGION OF HONOR IN SAN FRANCISCO

For many years, the Legion of Honor in San Francisco displayed a room of exquisite French boiserie, or detailed wood paneling. However, when the room was originally adapted to its setting in the museum, it was extended into a rectangle, and vitrines took the place of authentic French windows. Skurman Architects were invited by the museum's curator, Martin Chapman, to help restore the room's original proportions and detailing. They reinstated the windows to suggest the room's original setting in a Parisian hôtel particulier. The architects also added an antique parquet floor and columnar plinths. They replaced the previous, and entirely inauthentic, acoustic ceiling with a finely detailed plaster ceiling. Antique sconces and chandeliers were fitted with fiber-optic lighting for precise control of the space's illumination. With the addition of authentic eighteenth-century French furniture, the project team was able to put a room of historically correct French boiserie on display for the first time in an American museum.

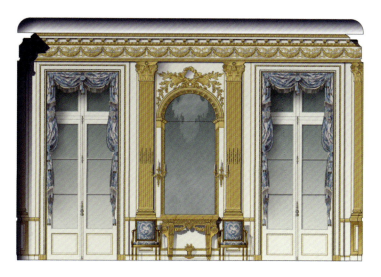
WEST FAÇADE

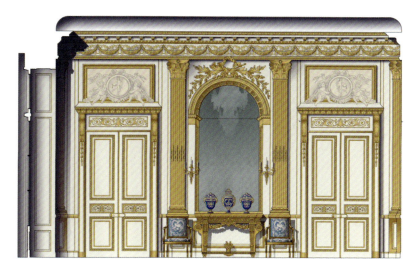
NORTH FAÇADE

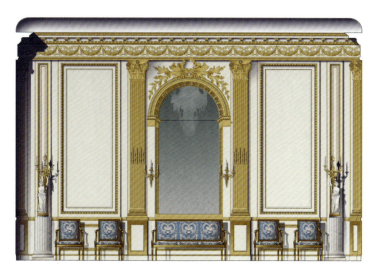
EAST FAÇADE

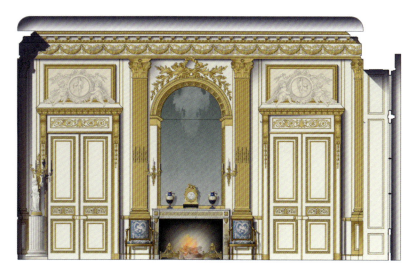
SOUTH FAÇADE

SUBURBAN VILLAS

"No great town can long exist without great suburbs," wrote the landscape gardener Frederick Law Olmsted in 1868. In this respect, San Francisco conforms to type. Topography has blessed it with numerous fine sites, often on the water, which are within easy striking distance of the city. Does anywhere offer a better quality of life?

As a word, suburb has been around for centuries. Chaucer's Yeoman lived "in the suburbes of a toun," although he did not rate the area. Honest citizens trod with caution in the suburbs. A degree of regulation and order prevailed in cities, protected and circumscribed by their walls; but the land immediately outside the walls was used for activities which the city authorities needed but could not stomach living amongst: slaughter houses, tanneries, prisons, brothels, and later, bear pits and theatres. This was the case with London's first suburb Southwark, on the wrong side of London Bridge. Since suburbs developed as a particularly English phenomenon, it may have been the first suburb in the world.

By the time of Samuel Pepys, however, the environs of London had come to be appreciated for other charms. Pepys himself spent the year of the Great Plague living "merrily" at Greenwich; his friends there—shipbuilders, merchants—had handsome houses with orchards, but could be rowed up to the City or the Court whenever necessary. Visiting Epsom in 1724, Daniel Defoe wrote of "Men of Business, who are at London upon Business all the Day, and moving to their lodgings at Night, make the Families, generally speaking, rather provide Suppers than Dinners: for 'tis very frequent for the Trading part of the Company to place their families here, and take their Horses every Morning to London … and be at Epsom again at Night." In what sounds like a perfectly agreeable way, commuting had begun.

On the Continent, the threat of marauding armies kept the citizenry crowded within their city walls. The British could risk living more expansively. In Charles Dickens's *David Copperfield* the solicitor Mr Spenlow lived in Norwood, surrounded by a garden, lawn, trees and trelliswork. The house itself is what the Victorians would have called a villa. Villa is another word with history. In this case it dates back to the Roman period, when it evoked the ideal life: a place of spiritual refreshment, amid gardens and views of Nature, for people whose business lay in the city. This idea is particularly appropriate to San Francisco, given its Mediterranean climate. Skurman Architects takes maximum advantage of the resonances. Elements of the plan may well be derived from Andrew Skurman's study of Hadrian's Villa, at Tivoli outside Rome, built in the second century AD, as larger properties often lead to larger plan-footprints with more opportunities for a hinge in the circulation.

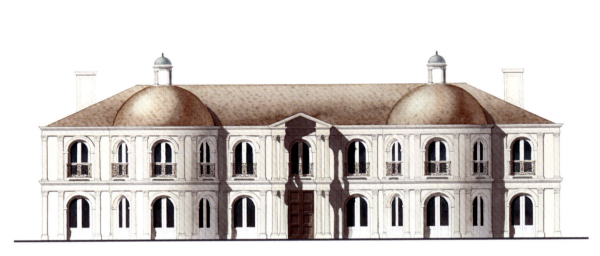

ENTRANCE FAÇADE

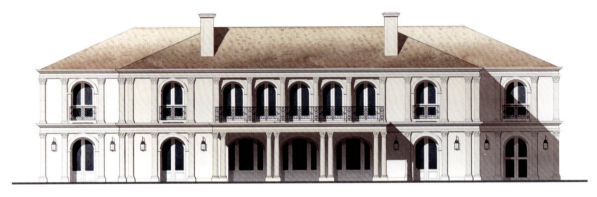

GARDEN FAÇADE

A Southern-French Renaissance Château

Skurman Architects was thrilled to have the opportunity to realize this southern-French-style château, in a manner distinctly reminiscent of the Château de Chambord. The house is clearly evocative of French Renaissance architecture, and its detailing follows the specific architectural culture of the Loire Valley during that period.

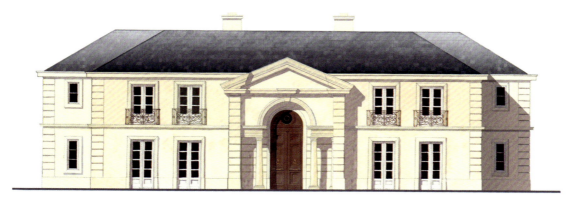

ENTRANCE FAÇADE

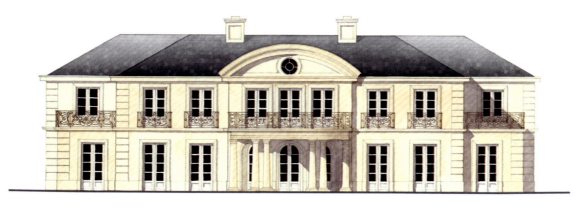

GARDEN FAÇADE

A Louis XVI Pavillon

This château was crafted in the style of French architecture from the reign of Louis XVI, and therefore in a decidedly eighteenth-century manner. The deep, entry portico and precisely articulated massing most closely recall the work of Claude-Nicolas Ledoux.

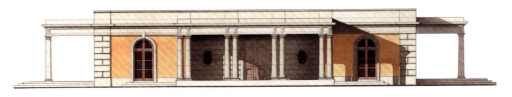

ENTRANCE FAÇADE

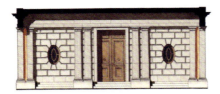

PORTE-COCHÈRE

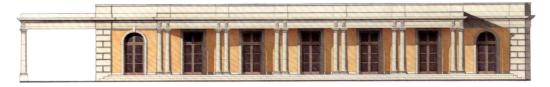

GARDEN FAÇADE

An Indo-Doric Palace

Skurman Architects was surprised and pleased to receive a call from India requesting their services for a new house project. The caller had seen a project of theirs in a magazine, and commissioned them to help him realize a neoclassical residence. Despite the difficulties of working on a project so far away, the team was especially pleased with the execution of the design. The house features an expressive and meditative repetition of the fully expressed Doric order throughout. The particularly rich integral color plaster was matched to a Roman renaissance precedent by a former intern in the office, who was at the time studying in Rome, and could visit the building in question.

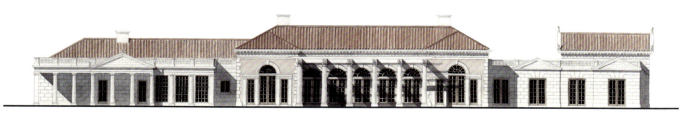

GARDEN FAÇADE

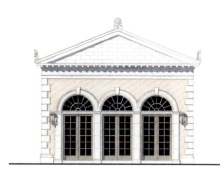 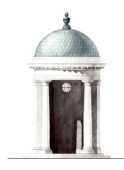 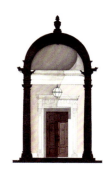

PAVILION DETAIL **ENTRANCE DETAILS**

A Classical Greek House

Greek classicism is the unmistakable source of inspiration for this generous and carefully detailed house. The project began as a renovation, but upon structural investigation the original building could not be retained. However, the revised and expanded massing respectfully references and builds upon the legacy of the original house. Nowhere is the Greek influence more pronounced than on the pediment above the arched primary bedroom windows, which is adorned with traditional carved acroteria.

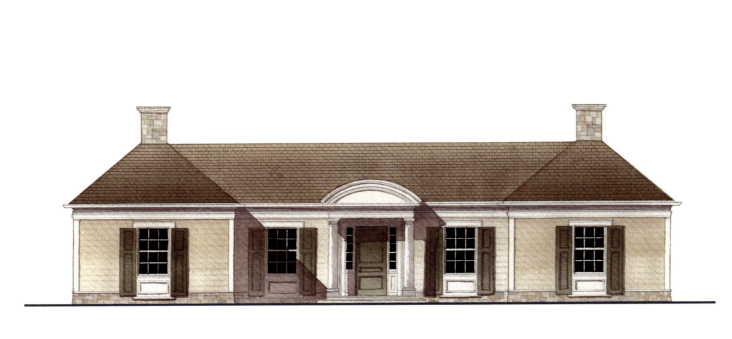

A Georgian Cottage

This new American Georgian cottage is laid out with a strict, even Palladian symmetry. A fully expressed Tuscan order carries the segmental pediment over the entrance. Architectural detailing is accomplished largely in wood trim painted white. Tall shutters over double hung windows reinforce the design's English heritage, while the choice of clapboard for the exterior finish is more suggestive of a colonial setting.

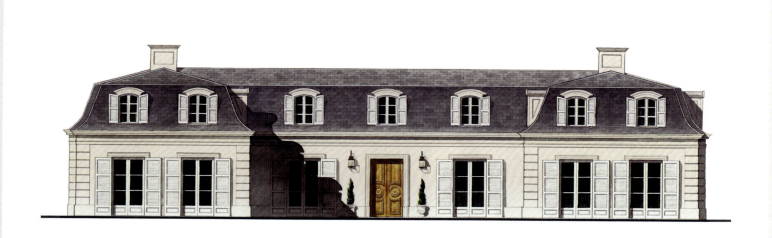

A French Pavillon

This grand residence, approached via a forecourt, is styled after the wonderful eighteenth-century pavillons of Versailles in the Louis XVI style. It also responds to considerable inspiration from the Pavillon Colombe, to the north of Paris between Sarcelles and Groslay. Enfilade-style circulation runs down both projecting wings that frame the sides of the courtyard. The characteristically French plan device of circular "hinging" rooms is also creatively deployed within. The house is capped by an unmistakably Parisian roofline punctuated by segmentally arcuated dormers, after François Mansart.

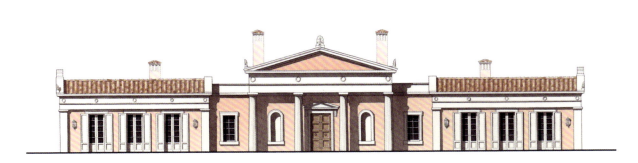

An Etruscan Villa

This is a prospective design for a house that was ultimately not built. Highly rigorous bilateral symmetry suggests a Mediterranean origin, namely Etruscan. The Etruscans were a pre-Roman culture that settled in the Northern and Central Italian peninsula, though the central volume features more explicitly Greek articulation. This can be seen in the acroteria atop the central pediment, as well as the fluted Greek Doric columns along the central portico. Greek Doric fluting comes to a sharp point, and their Doric order has no columnar base. Twin niches flanking the entrance are suggestive of Palladian motifs, as are the symmetrically paired chimneys.

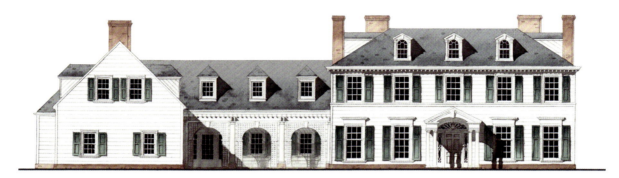

ENTRANCE FAÇADE

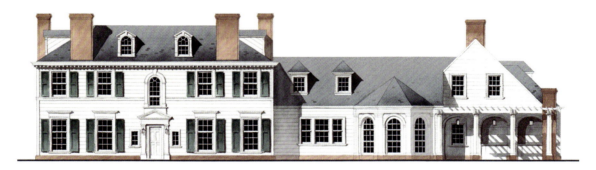

GARDEN FAÇADE

An Early-American Country House

The Virginia countryside was where Georgian residential architecture, as it became known in the U.S., was codified. This was revived as the American Georgian style by such notable practitioners as W. L. Bottomley in the early-twentieth century. As Georgian architecture is one of Skurman Architects' specialties, it was thrilled for the opportunity to design this classic American home with authentic Georgian detailing on a beautiful wooded lot.

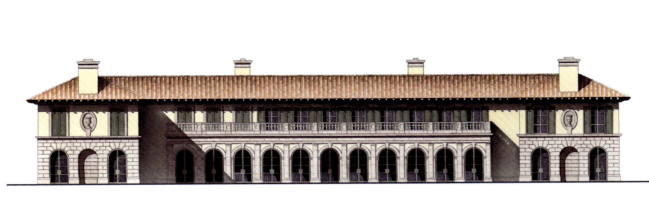

GARDEN FAÇADE

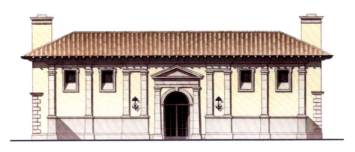

ENTRANCE FAÇADE

A Florentine Villa

This large new house, built south of San Francisco, was designed with the detailing of a large house in Florence. The typical Florentine palazzo features particularly heavy rustication on the first floor, and is highly porous to circulation on that level. In Florence, the street level of a large home was often rented out for commercial purposes, and typically contained a public or semi-public courtyard. Skurman Architects initially proposed this very classical and highly articulated version in yellow plaster with rusticated lower floor. The client ultimately preferred a version rendered in white, which is a more transitional or contemporary expression of the same elevation.

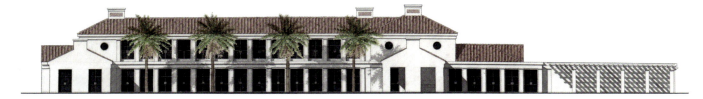

GARDEN FAÇADE

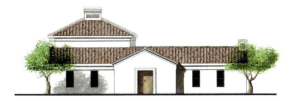

ENTRANCE FAÇADE

A Spanish Colonial Villa

This simplified Spanish colonial-style house, with plaster exterior and clay tile roof, is a new project in Northern California. Suggestions of a columnar order are made at the first floor between the double doors, and crown moldings of rectangular profile are featured throughout. The house features an enfilade-style floor plan to reduce the space lost to hallways on the first floor. This method was a signature of Paul Williams, perhaps the most notable architect of the Spanish colonial style in California.

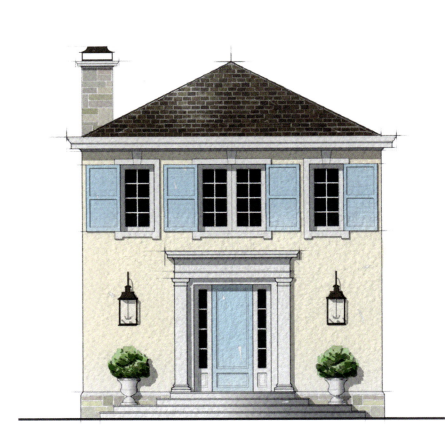

An English Cottage

This watercolor shows only the entry elevation of a much larger new home, designed in the Georgian tradition. Attenuated Tuscan order pilasters frame a simple yet dignified entry aedicule. Working shutters and a plaster exterior suggest a northern European locale. Crown and window trims in whitewashed wood are a clearly English touch.

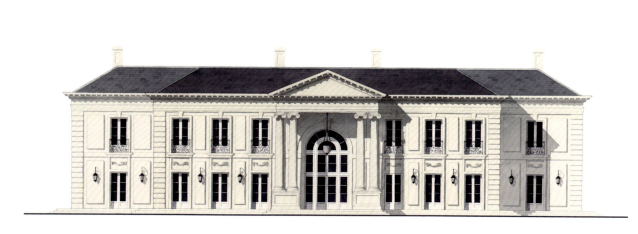

A Hôtel Particulier in India

This château in the French style is currently under construction in suburban Delhi. The office was pleased to learn that its past work in India inspired this owner to reach out to them. True French windows, where each window is in fact a double door, are the only kind of window on the property. The upper-level openings are accordingly detailed with fine ironwork, just as they are in Paris. Colossal paired Ionic columns support a pedimented portico, which leads to a double height entry and stair hall at the center of the house. The complete Ionic Order is canonically expressed, including architrave, frieze and denticulated cornice, throughout the exterior.

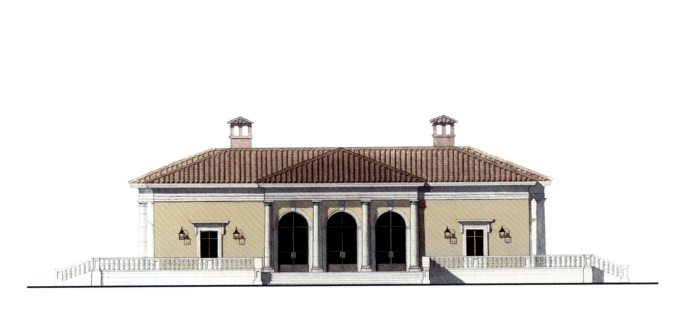

A Palladian Villa

Skurman Architects has completed a number of projects that suggest or recall the ground-breaking residential designs of Andrea Palladio. However, few of them can more directly trace their inspiration to his work than this one. Arguably the most famous of Palladio's houses in the Veneto, the Villa Rotunda features a square plan and four identical axial entrance porticoes. The plan and entrance schema for this house are arranged in the same manner. Like the Villa Rotunda, it is also a two-story house, but due to height limits in this municipality, the Skurman second story is beneath the first, and daylit with generous courtyards dug out on all sides.

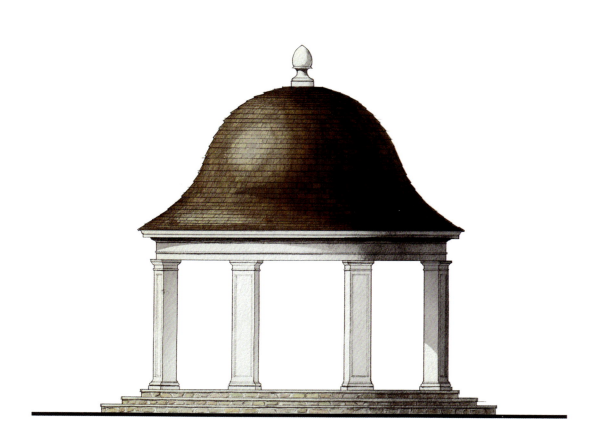

A Pavilion After de L'Orme at an American Georgian House

In northern California, there is great pleasure to be taken from a life lived largely outdoors. This renovation project allowed Skurman Architects to expand and dignify the property's outdoor spaces, and to more completely intertwine the house and the yard in celebration of such a lifestyle. Stylistically, their detailing drew heavily on precedents from Charleston, South Carolina, but there is no Charlestonian typology at play in this unmistakably Californian setting.

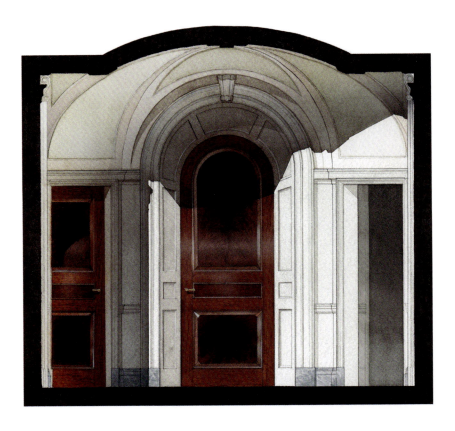

Section Through the Entrance Hall of a Georgian Penthouse Apartment

This is the grand domed entrance hall to a large San Francisco penthouse apartment, which is situated in a historic building overlooking the bay. Though less often captured in watercolor, the firm's work often involves the renovation of such apartments. This is a particularly fine example, with beautiful English detailing throughout. The raised panel doors are elevated with a special faceted detail at the corners of each panel.

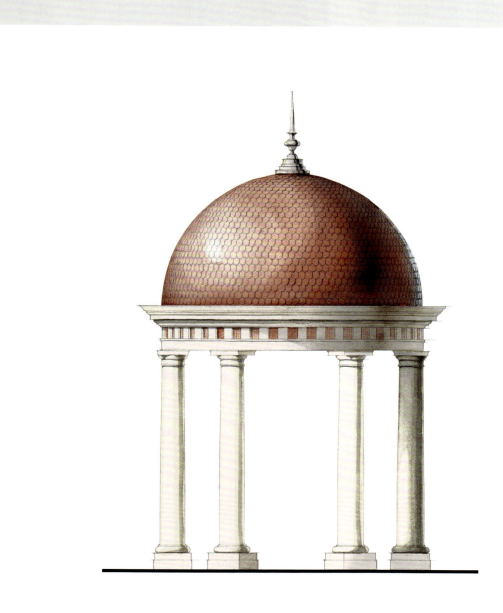

A Monopteral Temple at the Resort at Pelican Hill

This round Doric pavilion located at the Resort at Pelican Hill in Newport Beach, California, sits atop a bluff overlooking the Pacific Ocean. Skurman Architects was extensively involved in the design of the new hotel and resort. This particular structure has also evolved into the firm's logo. The pavilion is an especially popular location for wedding ceremonies.

COUNTRY ESTATES

"Country houses we have always had, and large ones too," wrote the architectural historian and connoisseur Barr Ferree in 1904 in *American Estates and Gardens*. But he thought he could identify a new type of dwelling—"sumptuous, often palatial in its dimensions, furnished in the richest manner and placed on an estate." Around 1900, according to cosmopolitan observers such as novelist Henry James, the European country houses—particularly those in Britain which was richer than other countries and had enjoyed a more settled history—achieved their ultimate expression as a mixture of art and life: a complete civilization for their lucky inhabitants, combining mellow architecture and well-tended gardens with dogs, horses, and shooting. This phenomenon was observed, emulated and excelled in the U.S., where architects such as McKim, Mead & White; Carrère and Hastings; Delano & Aldrich; and Horace Trumbauer (to name only a few) created numberless country houses around the great industrial and financial centers of the U.S.: there were 900 on Long Island alone. Many of these Gilded Age behemoths were demolished when the Depression struck and taste moved on. They represent, however, the beginning of an American tradition.

Visiting Long Island after the First World War, the Prince of Wales, the future Edward VIII and, after his abdication, Duke of Windsor, loved the country houses that he saw there. At home, big country houses with their unprofitable agricultural estates were often falling down; for all the status they bestowed, some owners were finding them to be as much a burden as a pleasure. Not so in the U.S. He found that everything there was modern. Houses were warm, comfortable, well-supplied with bathrooms—and they were built, not according to the outdated protocol of the past, but for

modern life. This meant convenience: not only were they close to cities but close to similar houses, so it was easy to bring in guests. There was none of the feudal obligation that European owners still felt towards the tenants on their land. Americans could sell up and move on, whenever they liked: they did not feel they were letting down their ancestors in doing so. Above all, the American country house was built for the sort of recreations rich people liked in the early-twentieth century, particularly sport. Swimming pools, gyms, tennis courts, even polo fields were laid on. When Edward returned to England he created his own version of a Long Island country house, Fort Belvedere, for what his unyieldingly conservative father George V called "those damn weekends, I suppose."

With its customary poise, Skurman Architects is a modern-day exponent of this American building type, designed in the many classical idioms of which it is master. Its country houses begin with the plan, making them as easy as possible for their owners to live in. Magically these practical requirements are then arranged so as to give joy to the eye, through the faultless craftsmanship of the architecture. Balance and symmetry create a mood of quiet and repose. As the American Beaux-Arts architect Donn Barber wrote in the introduction to John Cordis Baker's *American Country Homes and their Gardens* as long ago as 1906:

> Our country houses have a distinction of their own which arouses the respectful admiration of all who are competent to judge of their merits. They faithfully express our modern American civilization and show a certain sensible comfort to be found in no other land.

> The same is true today.

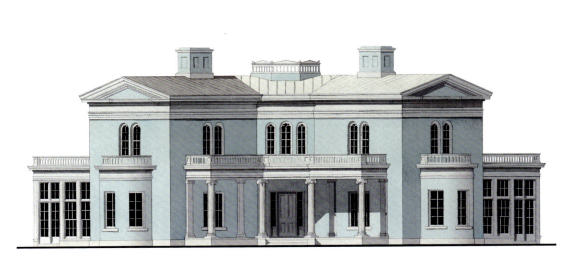

ENTRANCE FAÇADE

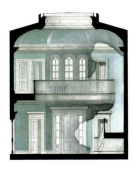

SECTION THROUGH STAIR HALL

An Anglo-Norman Country House

Work for this project began in a Jeep as the Skurman Architects team roamed around this glorious 1,000-acre property on a plateau high above the ocean, trying out different ideas for a site. Nestled among native oaks, and with nothing else for miles around, the site on which they landed still has the feeling of being well chosen. Inspiration came from a nineteenth-century American pattern book by William Rantlett. Rantlett's plan is described as a "Southern Plantation", but the cross-shaped massing of the four wings and clear Palladian inspiration defy this simplistic label. At the center of the house is a grand stair hall, capped by an octagonal skylight. The property features numerous porches detailed in the Ionic order, and a traditional greenhouse bringing the outside in from all directions.

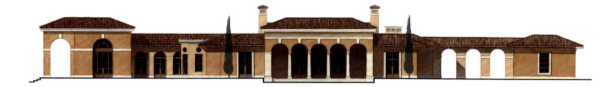

A TUSCAN VILLA

Despite the grandeur of this magnificent property, Skurman Architects were limited by the requirement of the local jurisdiction that no structure exceed 6,000 sq ft in size. Helpfully, the property consisted of three separate parcels, and so, the architects set about dividing the program of the estate across three buildings. The result is a playful and expressive dialogue between a central main house, and its slightly smaller pool house, and entertainment house dependencies. The houses feature variations of the Doric order, at times implied, and elsewhere, fully expressed. The materials are rustic and Italianate, with external walls of plaster detailed travertine, as well as rough-hewn, wooden accents, and clay barrel-shaped tile roofs.

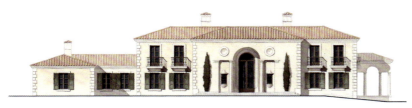

ENTRANCE FAÇADE

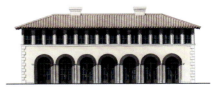

GUEST HOUSE FAÇADE

GARDEN FAÇADE

A Terraced Spanish Villa

This sprawling property including an amphitheater, tennis courts, and numerous dependencies revolves, on one side, around a highly axial, terraced water garden leading from the rear of the main house across a swimming pool, down numerous levels and eventually across a long reflecting pool to a classical pavilion set against the open sky. In the other direction, the garden axis continues through the front door of the main house and across a formal forecourt to the grand guest house. The strong central axis and numerous water features recall the Villa d'Este in Tivoli outside of Rome. The gardens of that villa, in turn, were one of the main inspirations for the landscape architects who conceived Versailles. In keeping with that multi-cultural legacy, the house features strong Italian influence, with Spanish Colonial interior architecture and an unmistakably Palladian front elevation.

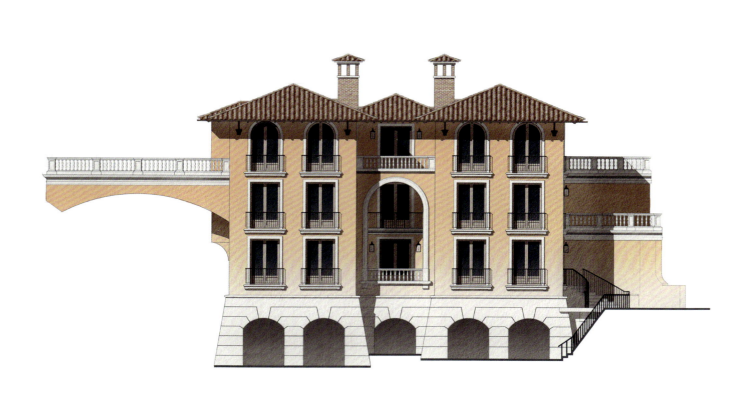

AN ITALIAN LAKESIDE VILLA

This remarkable waterfront site with its rocky beaches already suggested a kinship with the shores of Lake Como, and so to craft a house there, Skurman Architects went where Nature was already pointing. The significant gradient from the road to the water might have prompted a site further up the hillside. Instead the architects engaged the very shoreline with their foundations, and added a Swiss gondola that navigates its way up the steep hillside in style. Arriving in the living spaces below, and looking out the windows for the first time, you might think you had come to stay on a uniquely appointed ocean liner.

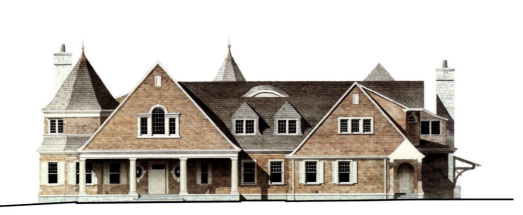

ENTRANCE FAÇADE

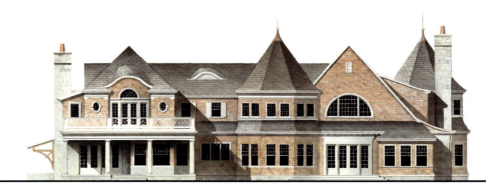

GARDEN FAÇADE

A Shingle-Style Cottage

Skurman Architects designed this grand shingle-style cottage for a client who ultimately did not proceed with the project. The American shingle style, most closely associated with Newport, Rhode Island, is a distinct American Georgian offshoot. Championed by, among others, the world-famous New York firm of McKim, Mead & White in the later-nineteenth century, it evolved from a regional peculiarity to an elevated and widely emulated form. This project was designed to use the white oak shingle siding which is typical in this style. Shingles of this species of tree turn silver grey with weathering. Georgian accents such as the Palladian window with fanned muntins, and four keystone oval windows, as well as a stout Tuscan portico place this design comfortably within the tradition.

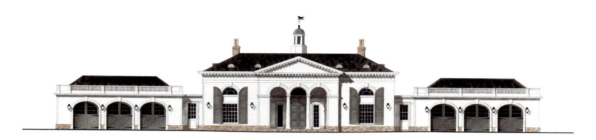

AN EQUESTRIAN ESTATE

This American Georgian equestrian estate is not, in fact, a straight line of three buildings as the watercolor would have you believe. Skurman Architects has drawn what's called an unfolded view of this U-shaped composition. The dependencies with their rows of arched carriage doors, flank a forecourt, and are attached to the main volume by L-shaped passages, known as hyphens. The central volume is composed from the exterior as if a single story, but the lunettes atop the main windows and entry door actually bring light into the attic. With its cupola and weather vane, the design evokes similar estates throughout the Virginia countryside near Washington, D.C.

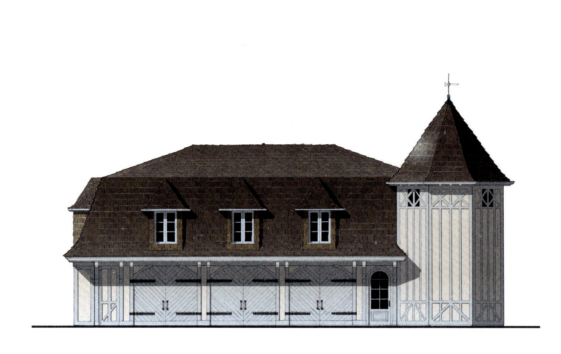

A Norman Manoir

Beyond the high classicism of Paris, there are numerous French building traditions of a more rustic and rural nature. California wine country is the perfect setting for such styles, given its similarity to the French countryside. Skurman Architects was delighted to expand upon this theme with the design of a country estate in the Normandy half-timbered style.

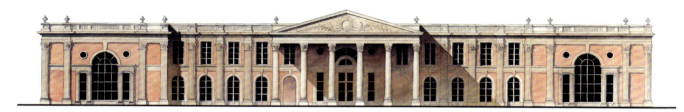

ENTRANCE FAÇADE

PAVILION DETAIL

A Palladian Palace

This project is one of the earliest taken on by the Skurman office, and is still one of the largest. It is a grand palace to be sure, with the fully expressed Corinthian order throughout the exterior, including a massive six column porte-cochère. Inspiration for the design came from Palladio, one of the most experienced Renaissance architects in the practice of realizing such grand residences. The material palate was inspired by the secondary buildings at the Château de Vaux-le-Vicomte, the exteriors of which are are all brick with carved limestone detailing. The roof was finished entirely of copper, which with patina will turn bright green within the first quarter of its projected 100-year life.

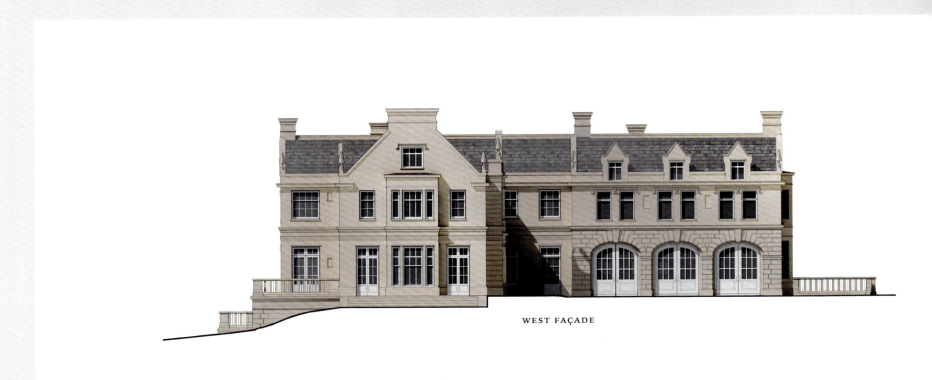

WEST FAÇADE

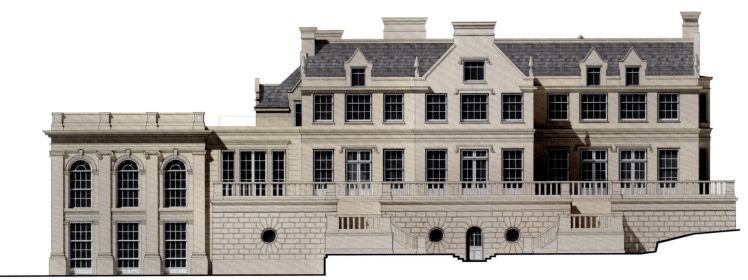

NORTH FAÇADE

COUNTRY ESTATES

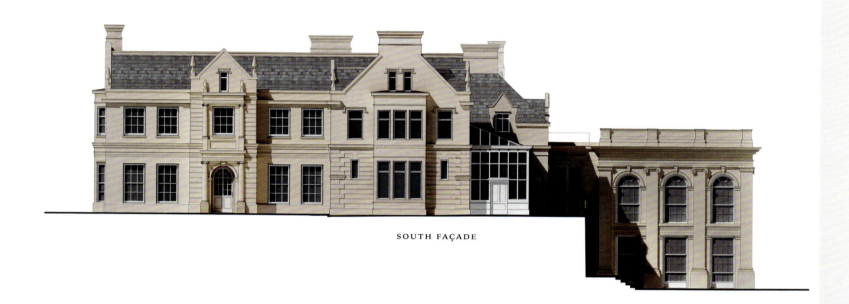

SOUTH FAÇADE

AN ENGLISH COUNTRY ESTATE

The Skurman office is very excited to be working on this project, which will be a new home in the style of an English country estate. Particular inspiration was taken from a number of notable historic homes in England, including Stoke Rochford Hall, outside Grantham, and Lucknam Park, outside Chippenham, for their gabled rooflines. The composition of the secondary volume overlooking the garden and detailed with the Ionic order was inspired by the Palladian-style bridge at Prior Park in Bath. The descending semicircular stair to the undercroft is borrowed from the Galleria Borghese. The property will be augmented with a generous terraced garden designed by Wirtz International in Belgium, and arranged, much like the house, in the picturesque and romantic style of similar gardens in England.

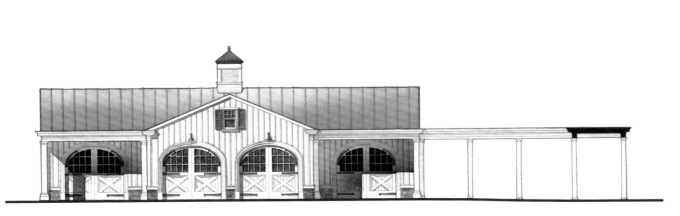

CARRIAGE HOUSE MAIN FAÇADE

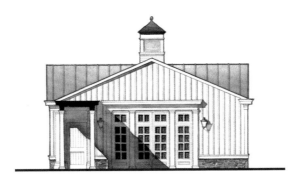

CARRIAGE HOUSE SIDE FAÇADE

An American Country Estate

These renderings depict the carriage house of a small estate property designed in the American Georgian tradition. Skurman Architects lightly renovated the exterior of the main house to introduce greater compositional harmony, and extensively revived its interior. To make the property a true estate, the architects added appropriate secondary buildings including a guest house and carriage house. These were designed to look like equestrian buildings: common dependencies on similar estates.

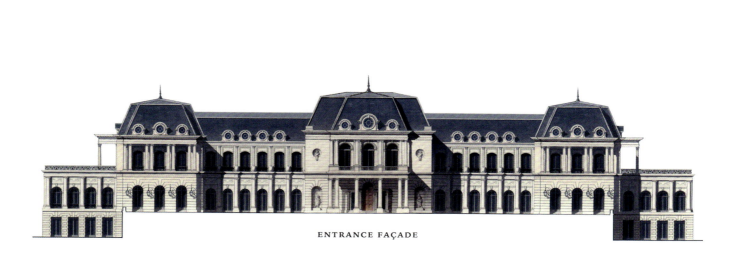

ENTRANCE FAÇADE

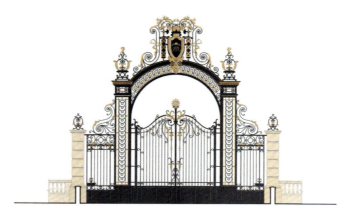

GATEWAY DETAIL

A French Palace

This project is for a new estate overseas, built for a local Francophile. It is designed and detailed in the style of a grand French palace. Skurman Architects was initially inspired by the Palace of Versailles, which is the epitome of French residential architecture. The project was meticulously realized in close collaboration with a local architect of record and general contractor.

PHOTOGRAPHIC RECORD

Elevational drawings express the essence of architecture; photographs capture its materiality. The following pages evoke the moods and textures that the watercolors, in their controlled beauty, leave out. We see a tightly disciplined Ionic column juxtaposed to a gnarled and spreading tree, a belvedere next to palm trees overlooking the water, doors opening from hallways to reveal glimpses of the world outside the house. This is architecture that takes its key from its setting, adding contrast and heightening the atmosphere.

What architects can picture in their minds requires the eye of a photographer to dramatize for the world at large. A row of balusters can look like guardsmen on parade. Isolated by the lens, a detail commands the reader's attention, whether it is the curvaceous wrought-iron that decorates a glass door or the swoop of a staircase. Looking up, looking down—a flamboyant canopy over a front door, the arch of a doorway inside a house: the pairing of images can reinforce the visual effect, creating its own sense of delight.

These photographs also convey something of the richness of Skurman Architects' work. However sparingly it may be used, ornament is an integral part of the classical styles in which they design. It not only requires architectural knowledge to design, but skill to execute. Fortunately, there are still craftspeople about who can carve columns out of limestone, fashion the finest wood paneling, and lay decorative marble floors. A scrolling, iron staircase-balustrade not only adds a sense of movement to a restful hallway but is a fit subject for contemplation, not least for the brio with which the Skurman design has been realised by the ironsmith.

Another ingredient of classicism is repetition. The same elements are reproduced numerous times across a façade—and ideas that have been introduced on the exterior of a building may also find expression on the inside. The effect combines grandeur with a sense of pleasing calm. Similarly, the decorative language of classicism, first used in Ancient Greece, exploits the shadows cast by the strong sunshine to define the mouldings. It is therefore well suited to California, with its Mediterranean climate. The architecture seems to change as the sun moves through the sky, highlighting different elements depending on the angle of the light. This is as true of a coffered ceiling in a drawing room as it is of a pediment over a front door.

Photographs are then needed to convey something further about the architecture of these homes, and that is the tactile experience of being inside them. Obviously they are comfortable, in the sense of being pleasant places to sit, talk, read, relax or eat. But they also provide an inner comfort from the orderliness and repose of the architecture. Our photographs show a world from which the grittiness and chaos that may exist elsewhere on the planet has been excluded, to the benefit of the owners' happiness.

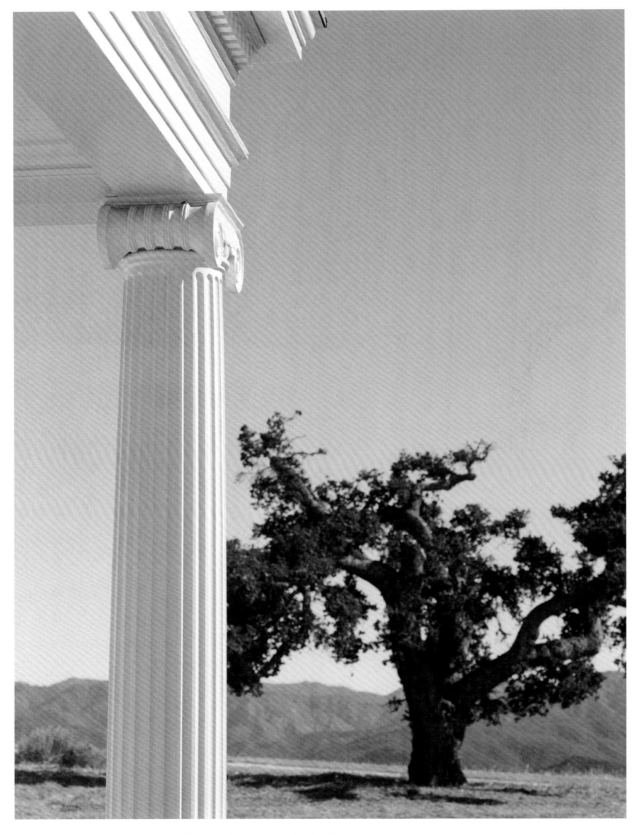

Ionic Column at an Anglo-Norman Country House

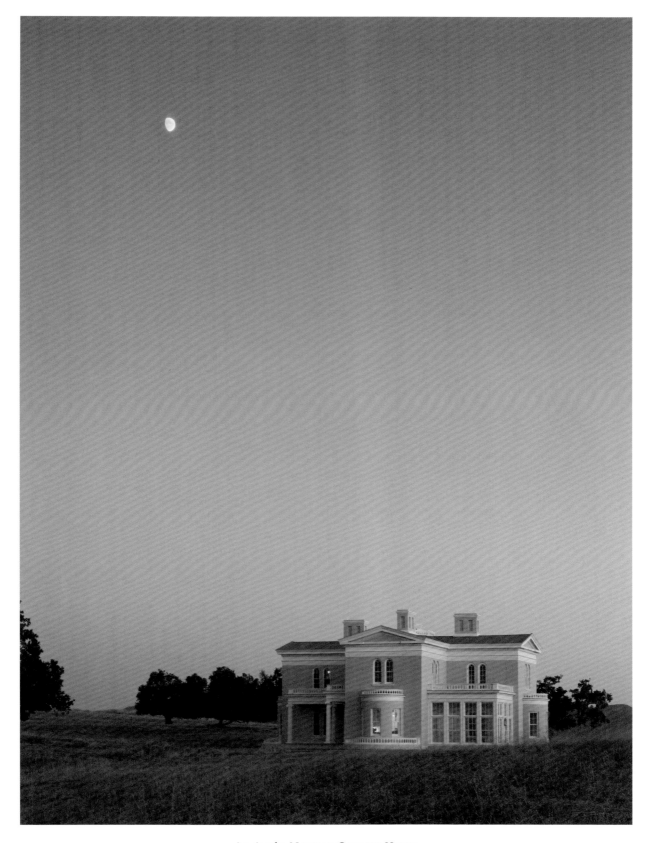

An Anglo-Norman Country House

PHOTOGRAPHIC RECORD

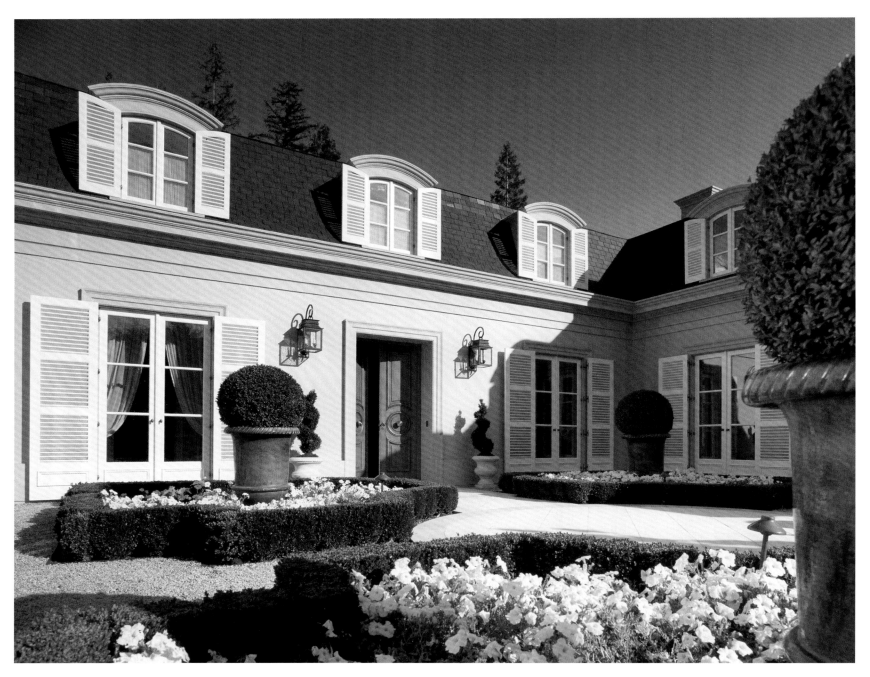

A French Pavillon

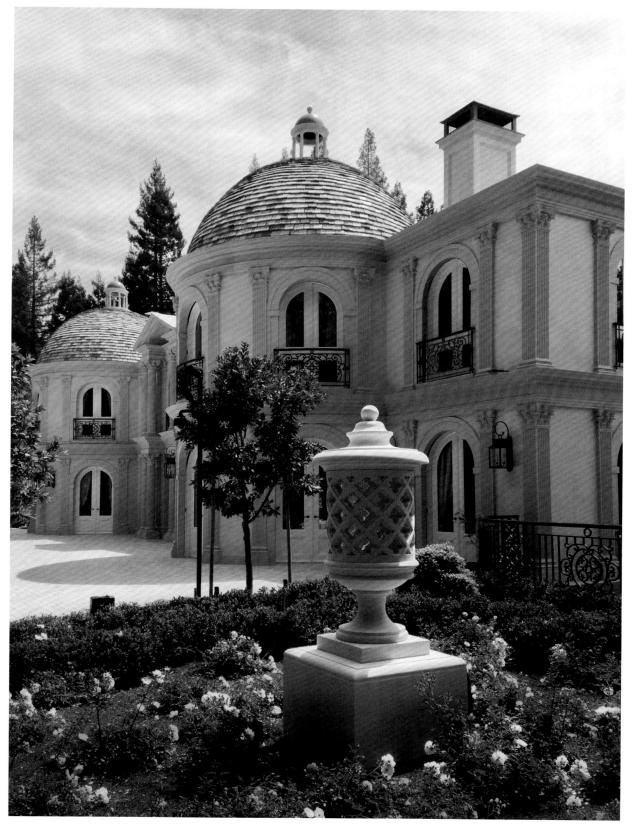

A Southern-French Renaissance Château

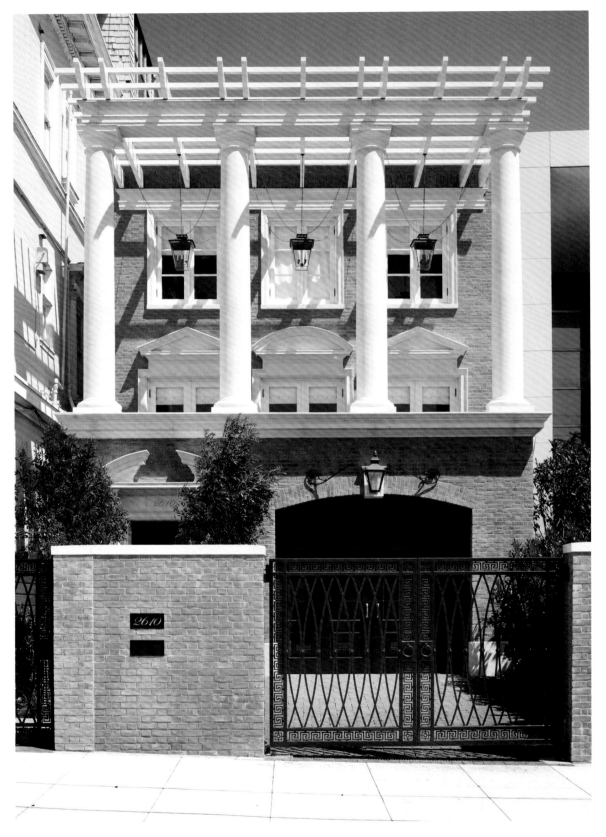

A Georgian Townhouse

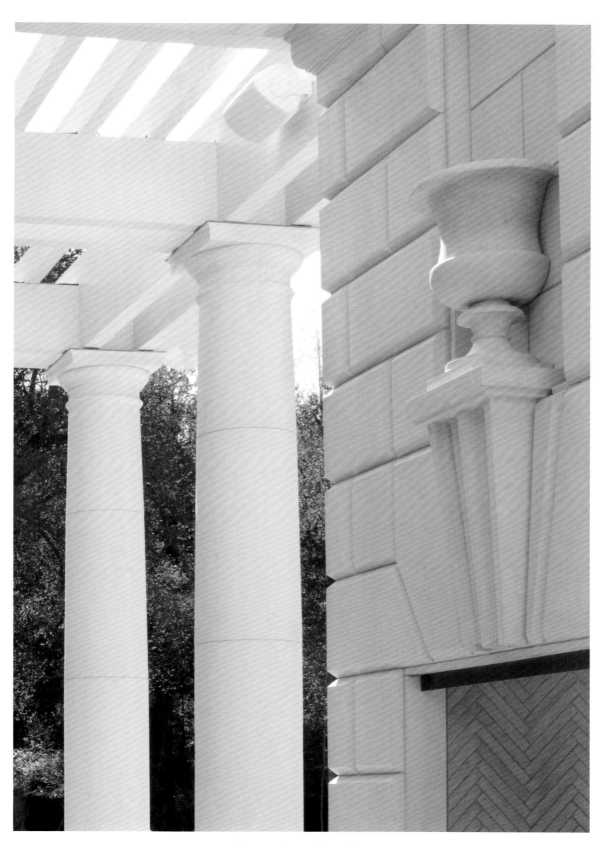

Pergola at a Classical Greek House

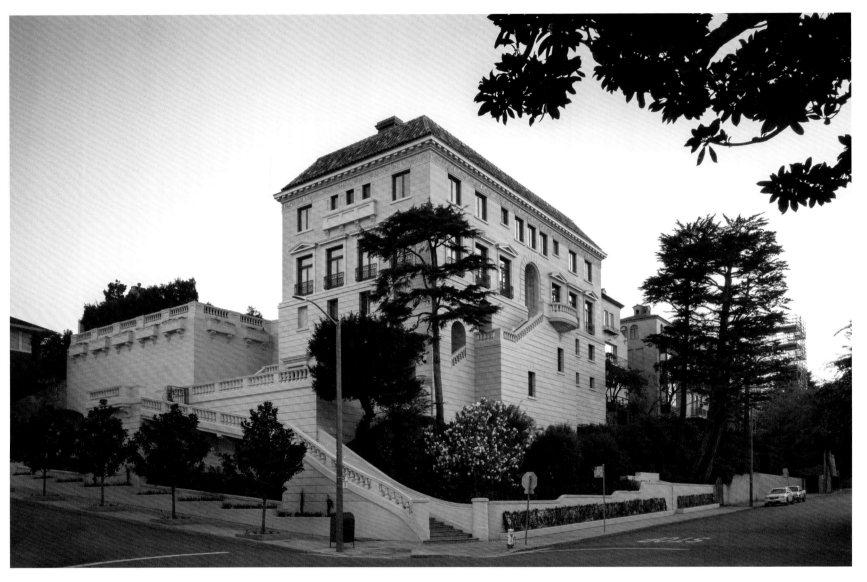

An Italian Palazzo

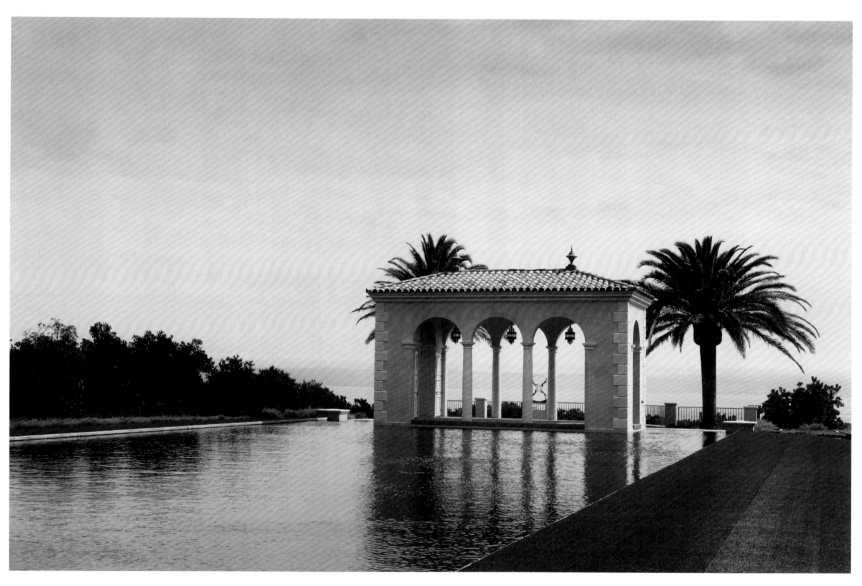

The Reflecting Pool at a Terraced Spanish Villa

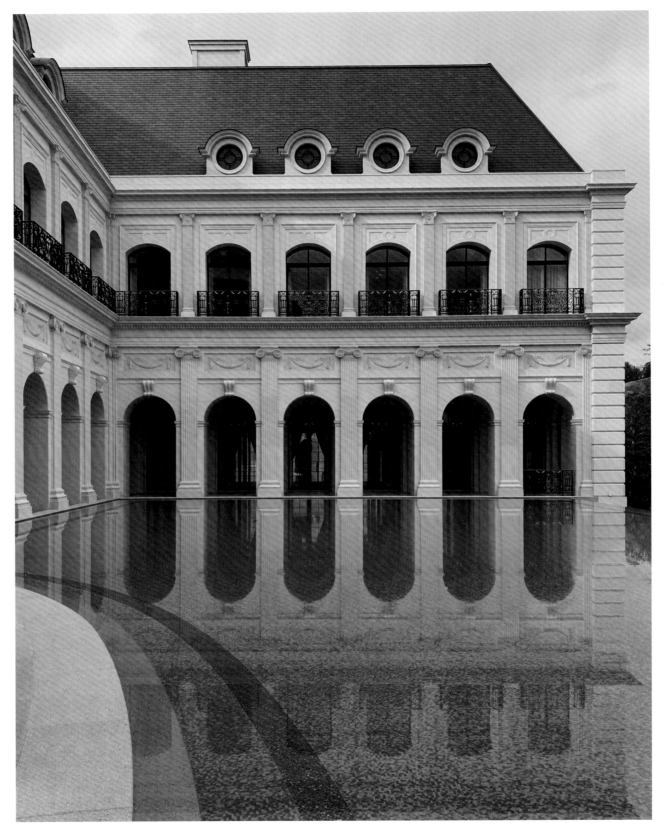
A French Palace

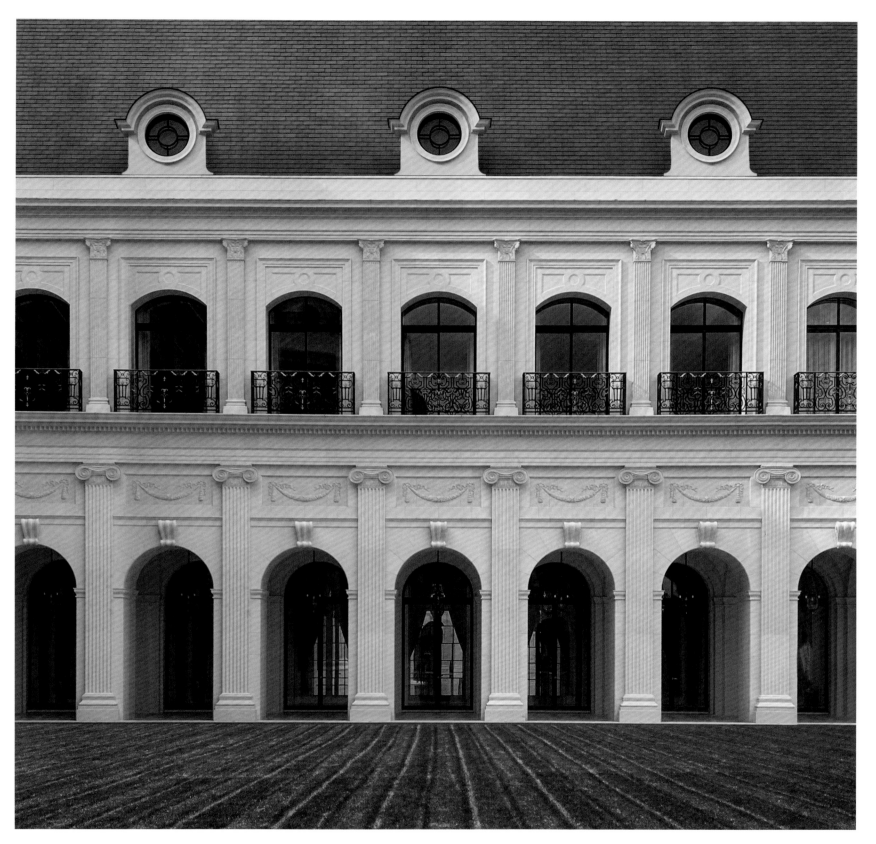

A French Palace

A Southern-French Hôtel Particulier

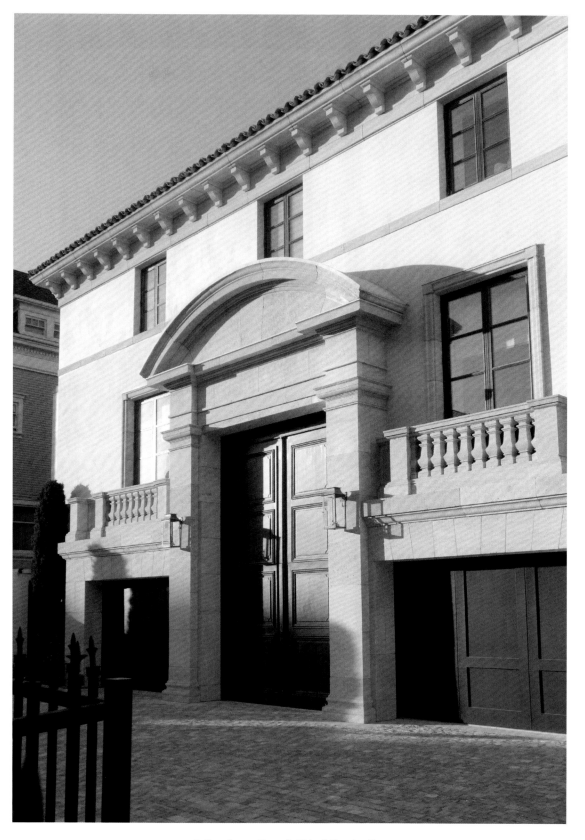

A Southern-French Hôtel Particulier

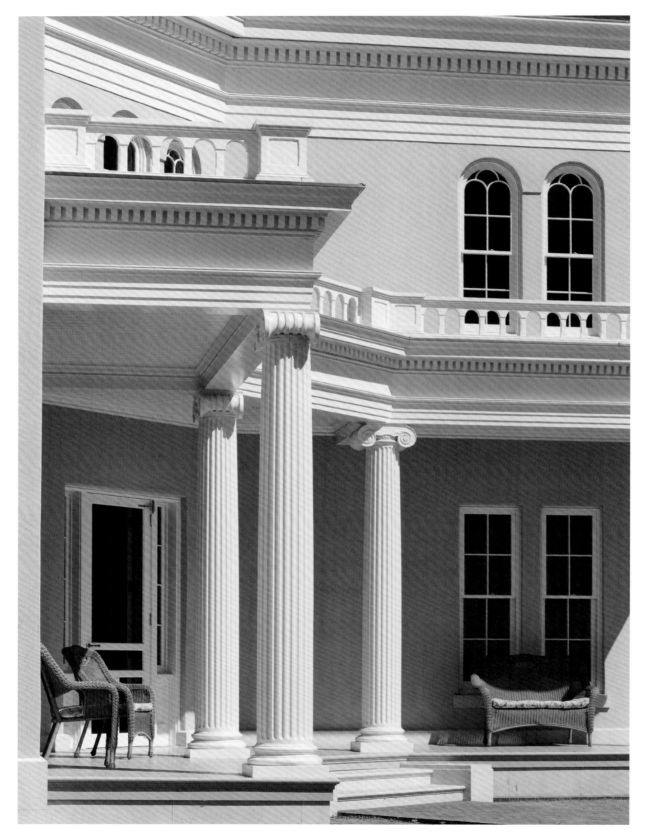

An Anglo-Norman Country House

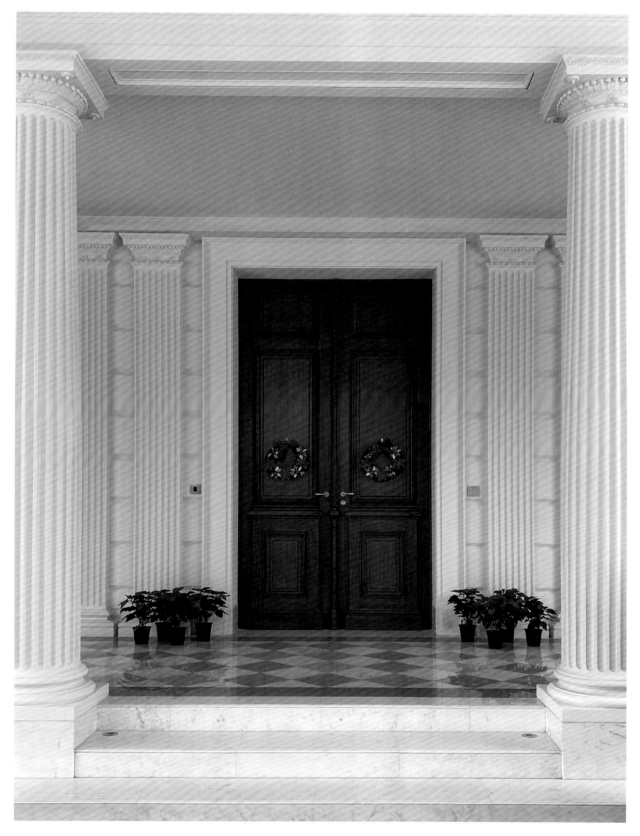

Entrance to an Indo-Doric Palace

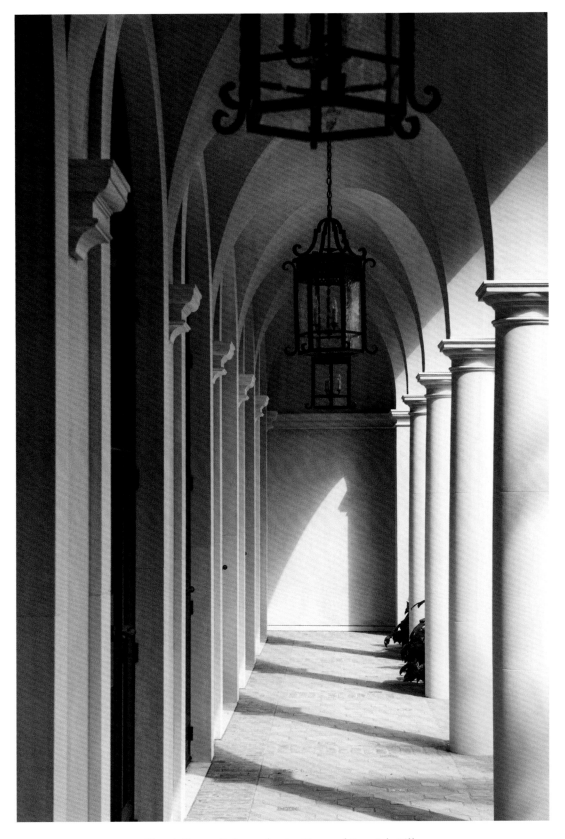

Guest House Colonnade at a Terraced Spanish Villa

Balustrade Detail at a Terraced Spanish Villa

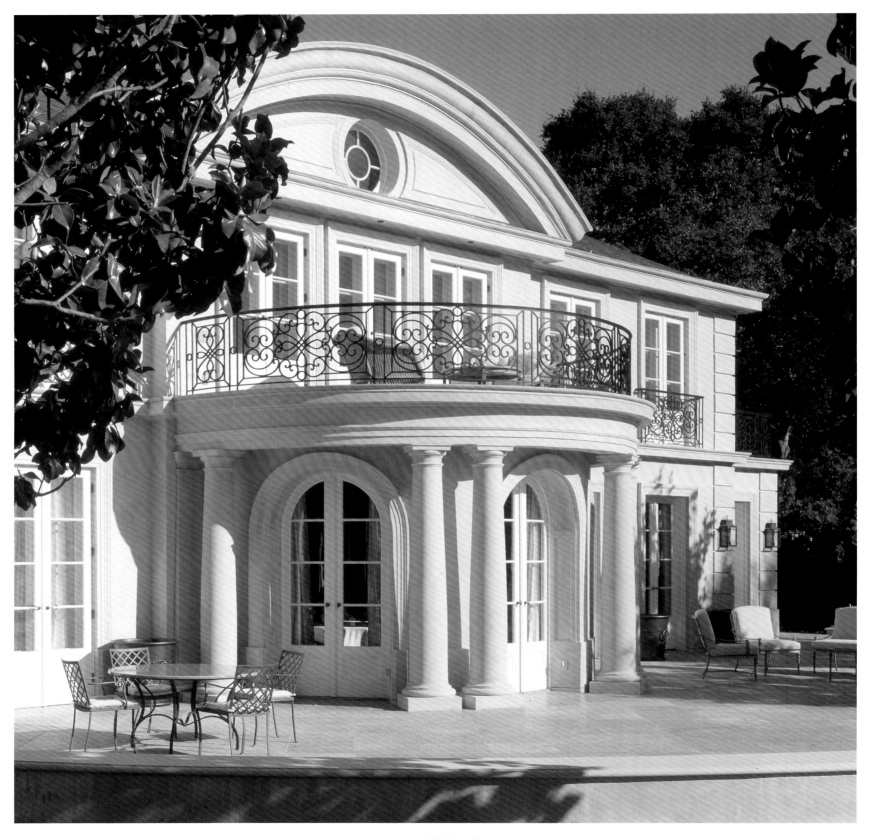

A Louis XVI Pavillon

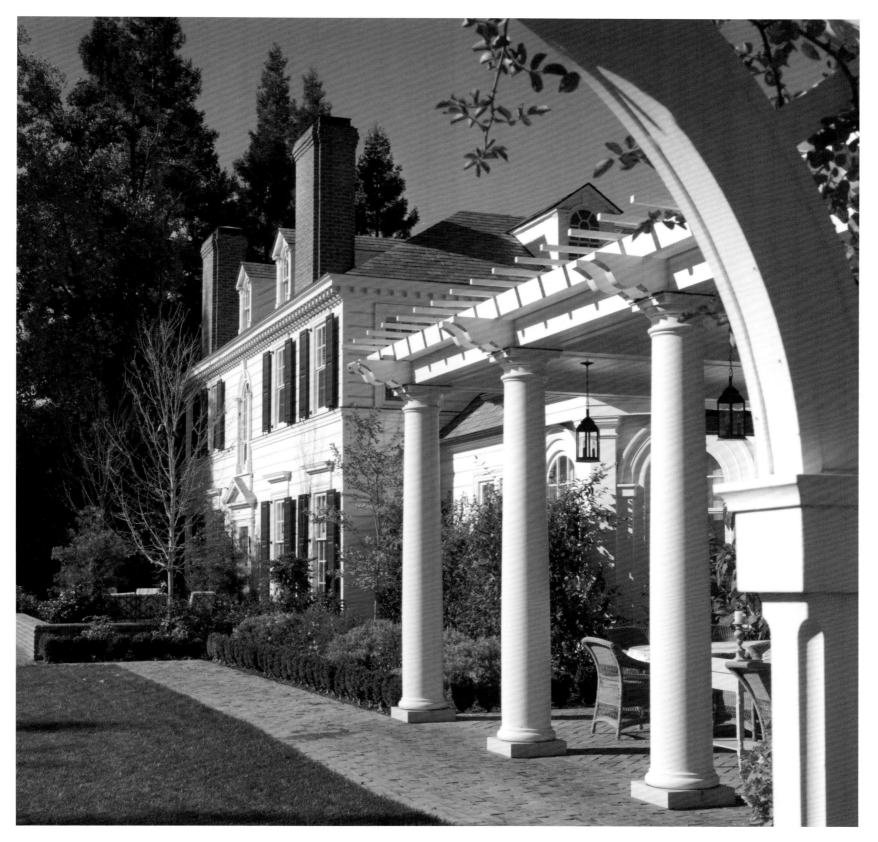

An Early-American Country House

PHOTOGRAPHIC RECORD

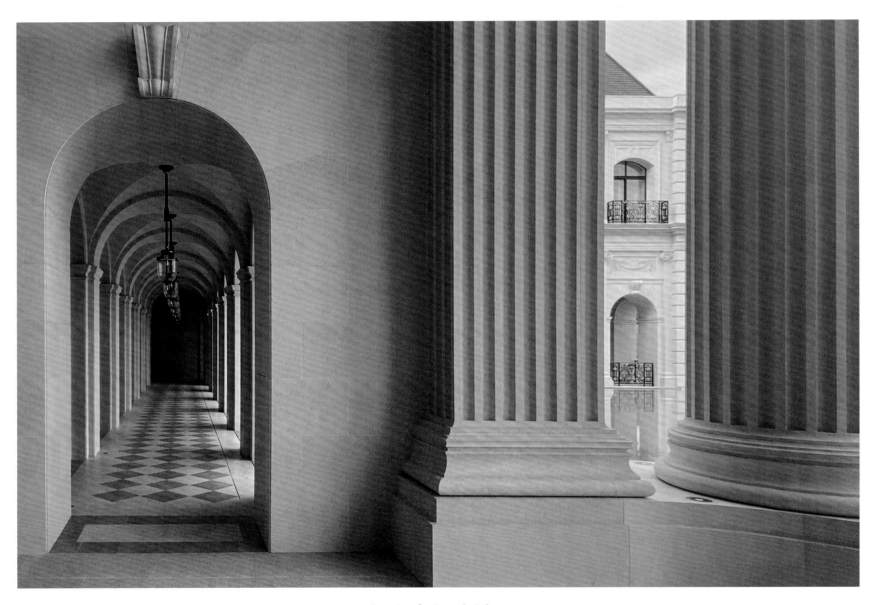

Loggia of a French Palace

Entrance to a Louis XVI Pavillon

Entrance to a Georgian City House

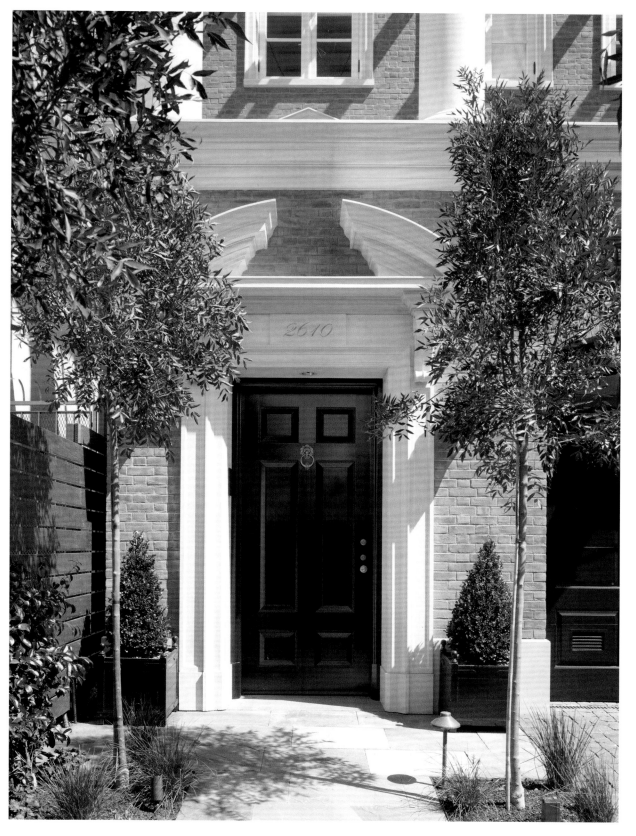

Entrance to a Georgian Townhouse

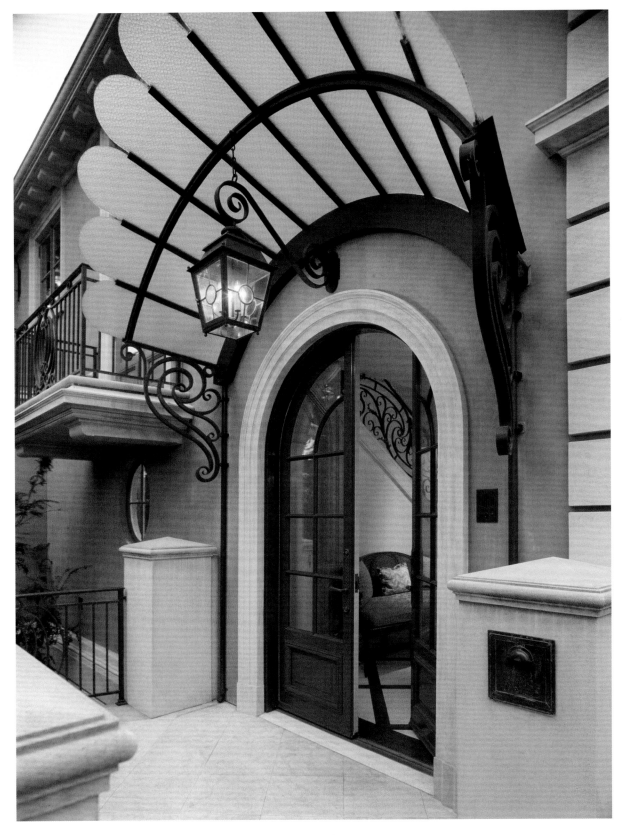

Entrance to a French City House

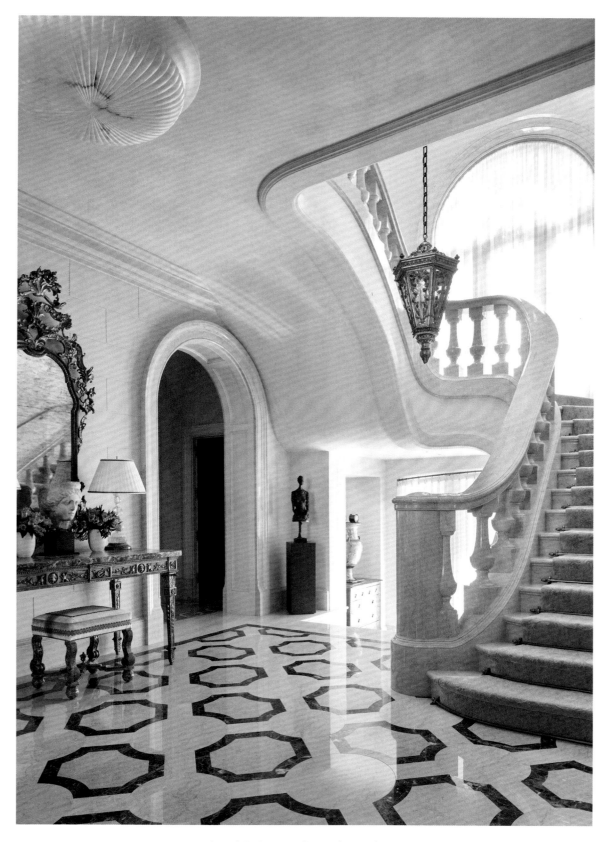

Grand Staircase of an Italian Palazzo

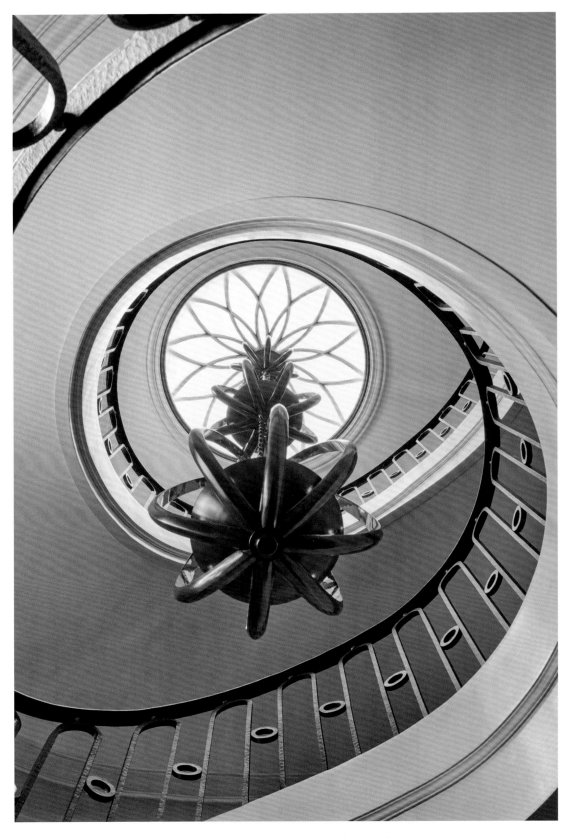
Spiral Staircase of a French Hôtel Particulier

Domed Bronze Laylight in a French Hôtel Particulier

Staircase of a Tuscan Villa

Staircase of a Spanish Hillside Villa

Stair Hall Ceiling in an Italian Palazzo

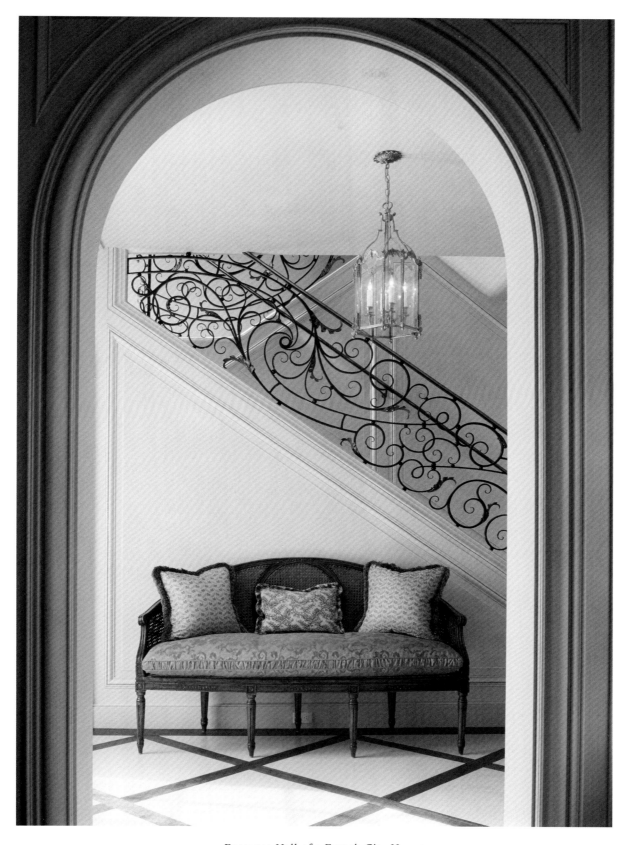

Entrance Hall of a French City House

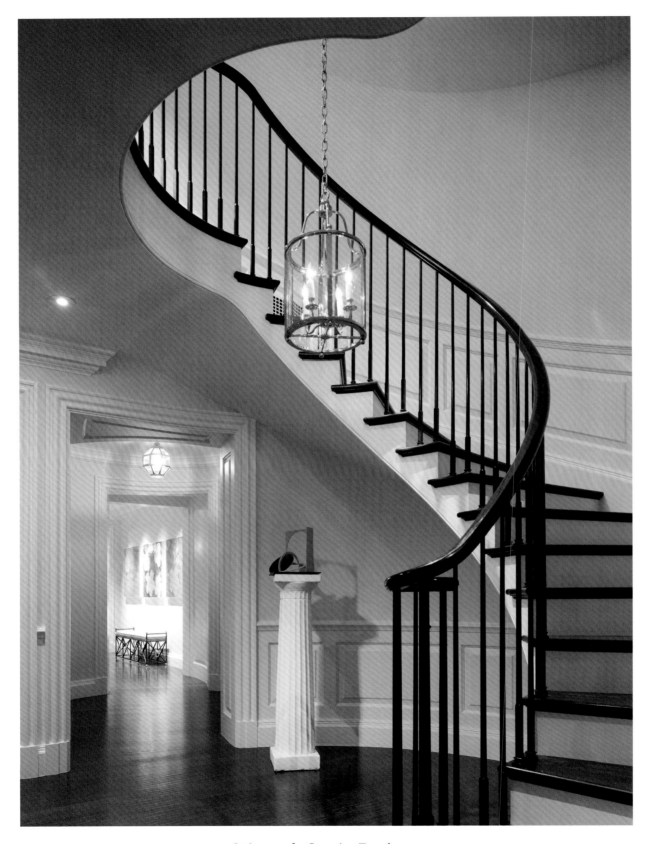

Staircase of a Georgian Townhouse

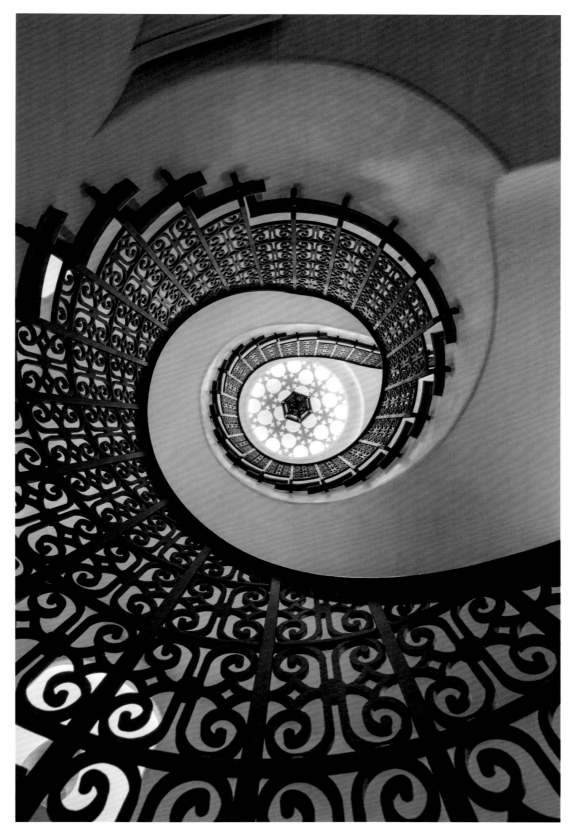

Staircase of a Terraced Spanish Villa

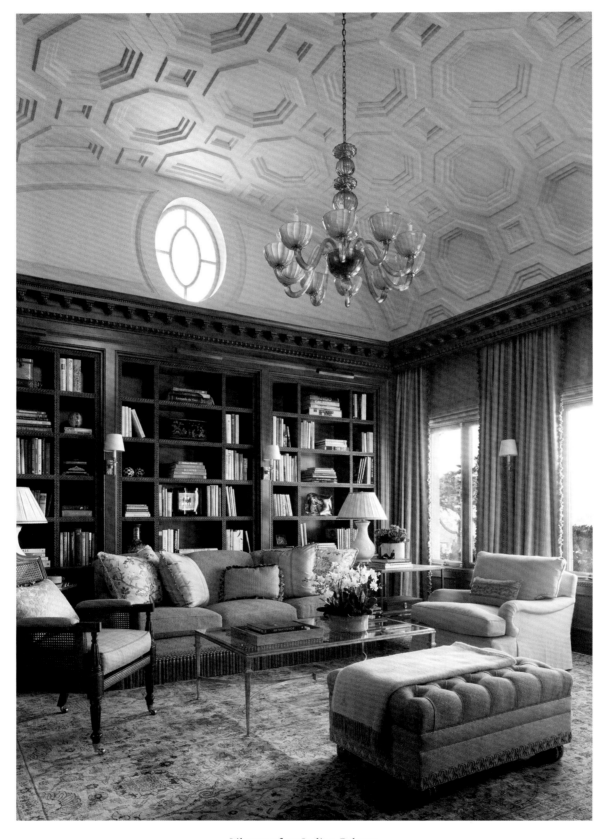

Library of an Italian Palazzo

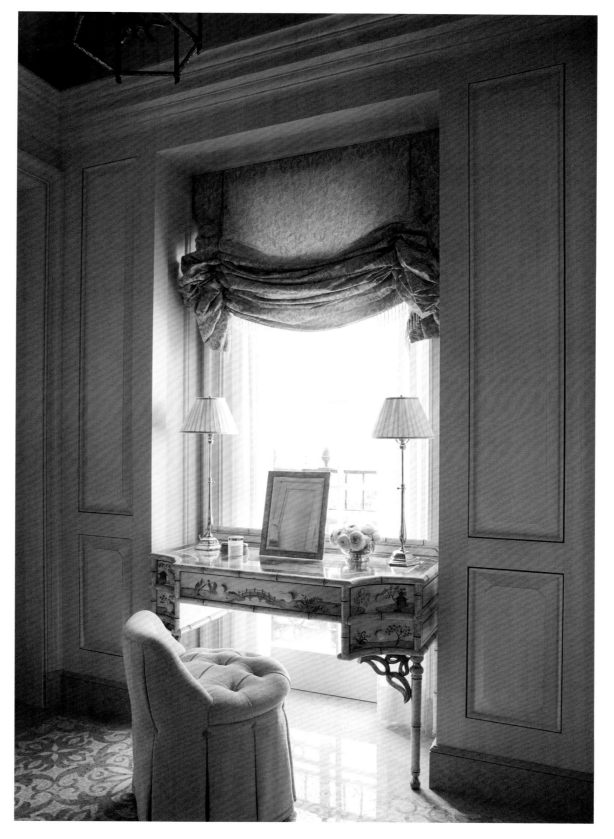

Dressing Room in a Georgian Penthouse Apartment

Entrance Hall of a Spa at the Resort at Pelican Hill

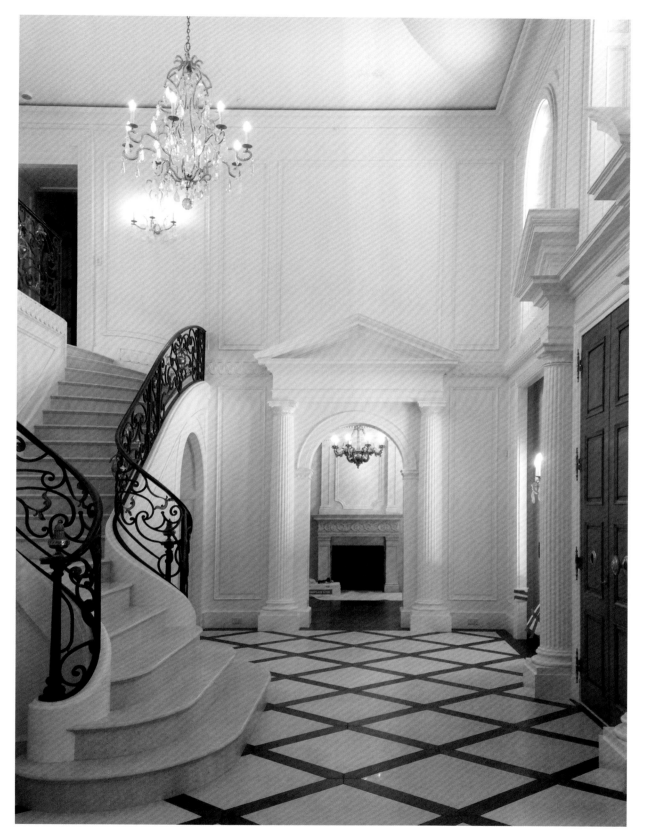

Entrance Hall of a Southern-French Renaissance Château

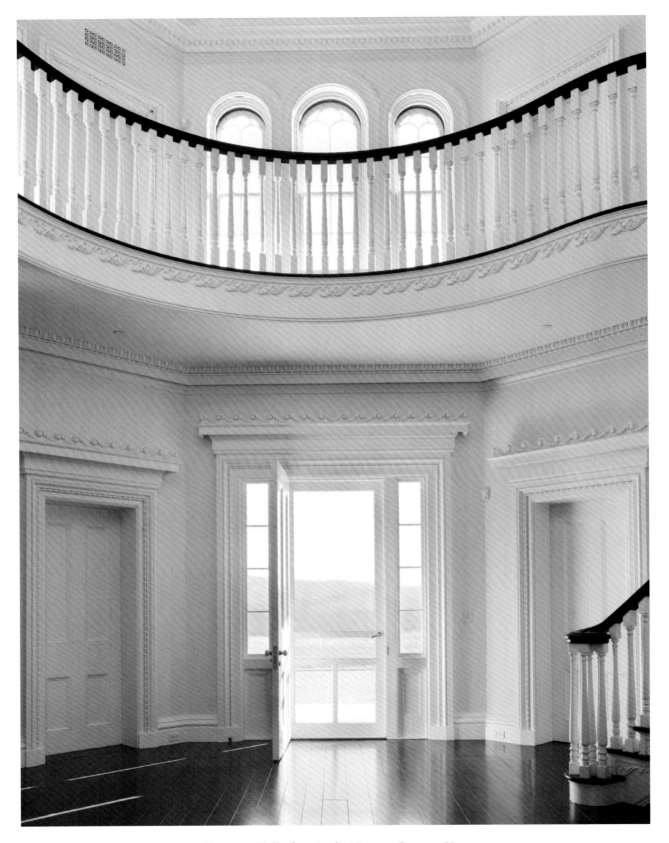

Entrance Hall of an Anglo-Norman Country House

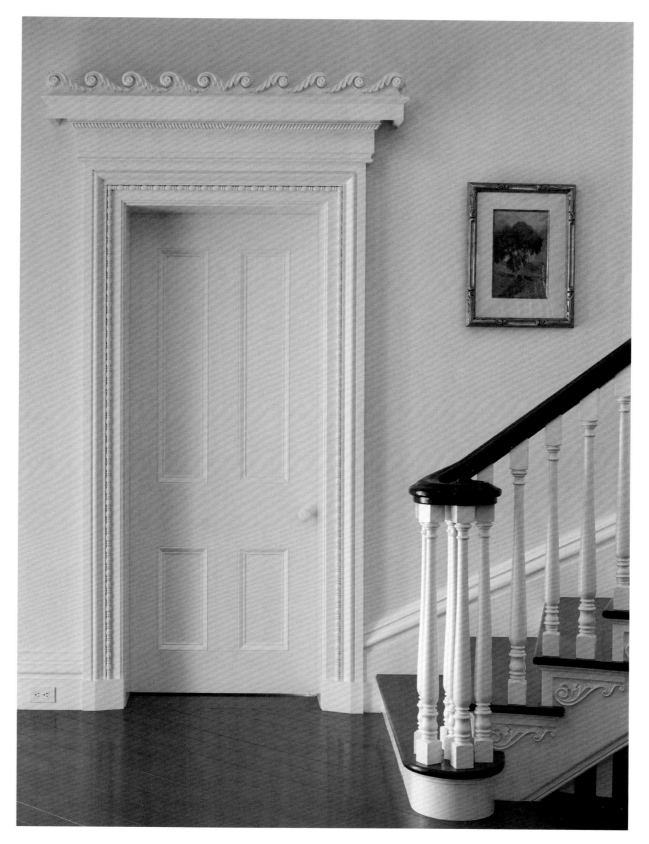

Doorway Detail from an Anglo-Norman Country House

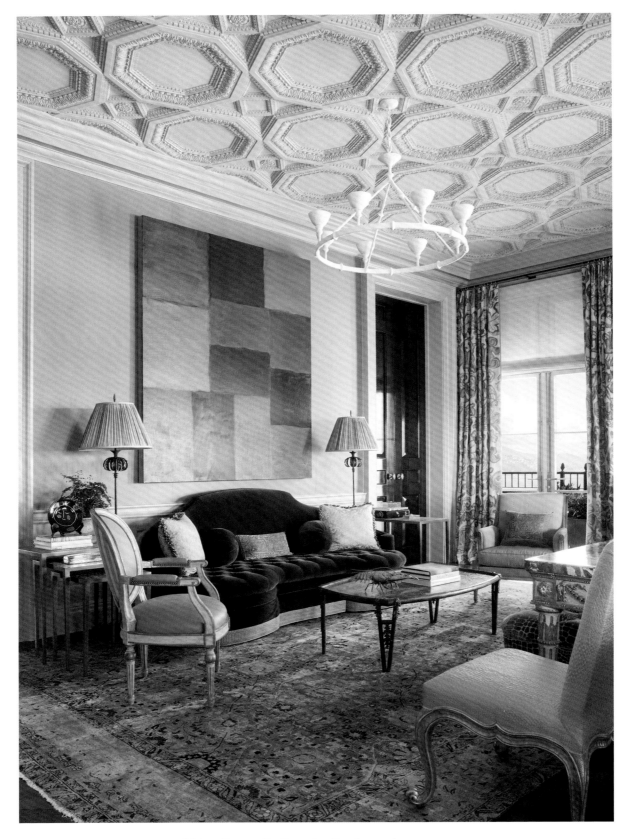

Living Room of a Georgian Penthouse Apartment

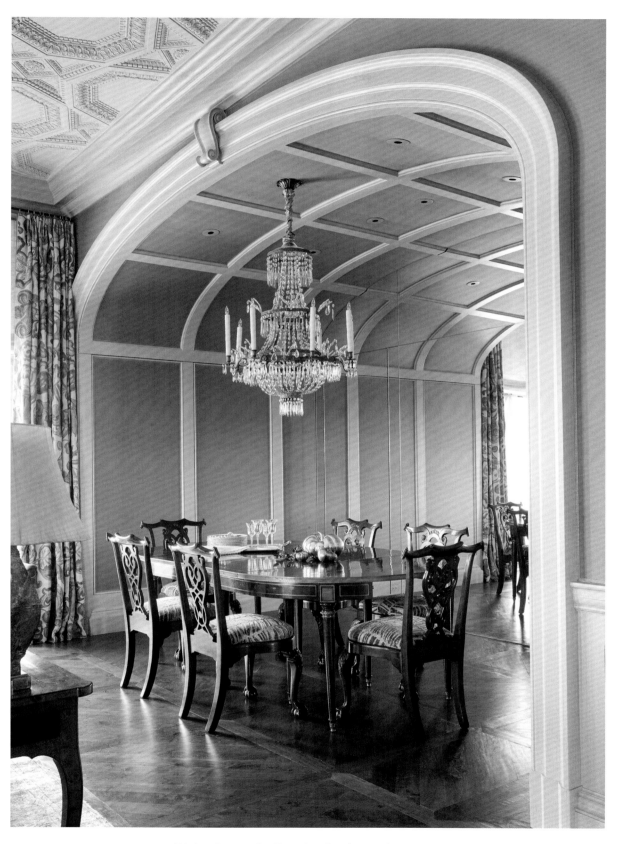

Dining Room of a Georgian Penthouse Apartment

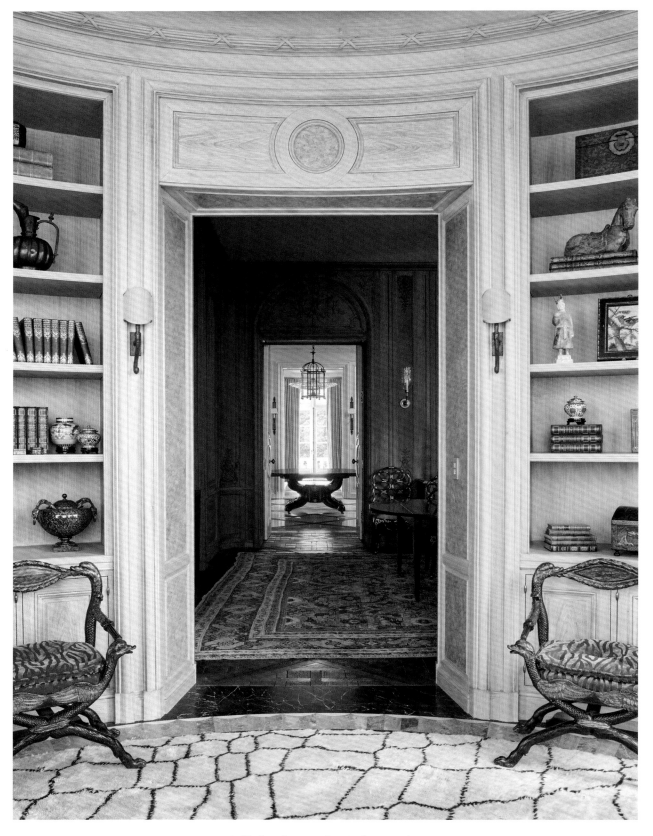

Enfilade of a French Hôtel Particulier

Detail of Antique Dining Room Paneling in a French Hôtel Particulier

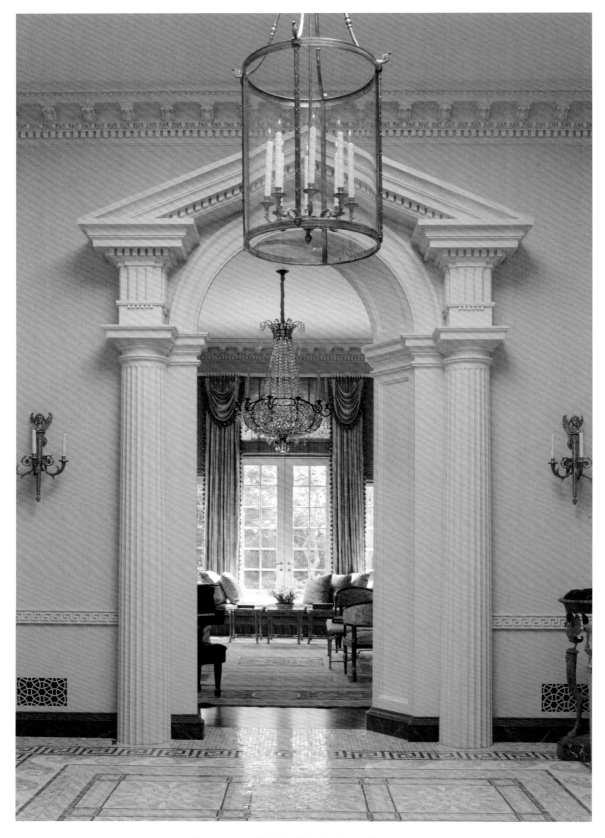

Entrance Hall of a Classical Greek House

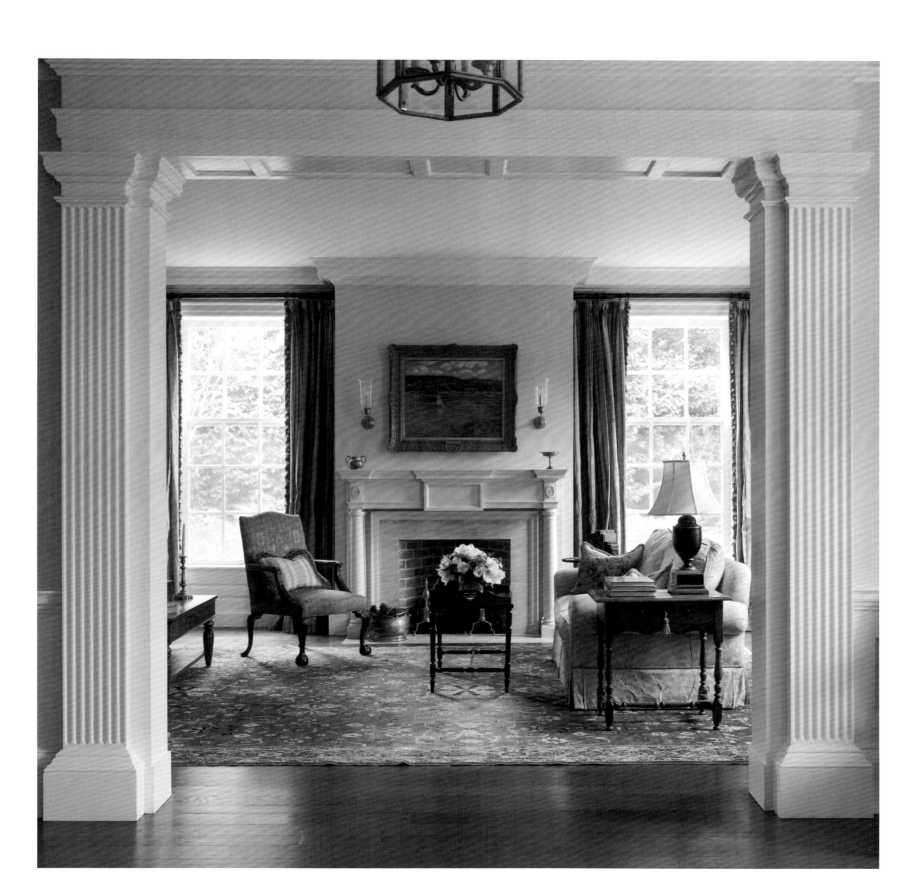

Living Room of an Early-American Country House

Door Detail from a Georgian Penthouse Apartment

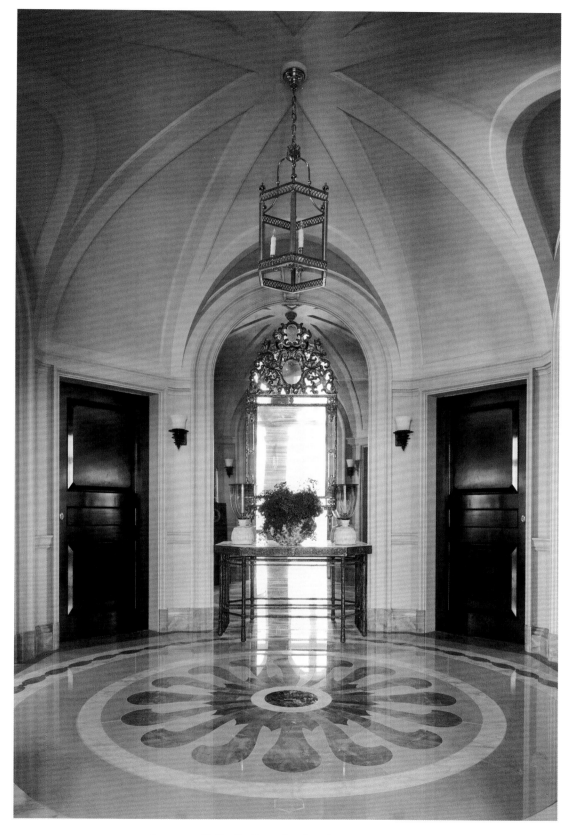

Entrance Hall of a Georgian Penthouse Apartment

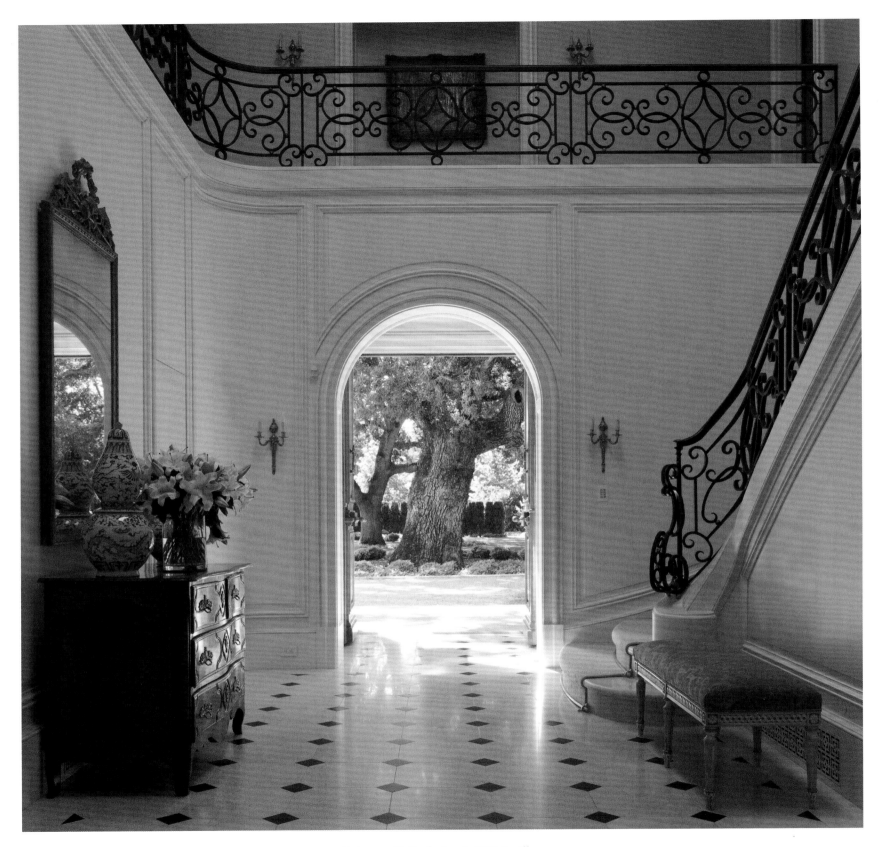

Entrance Hall of a Louis XVI Pavillon

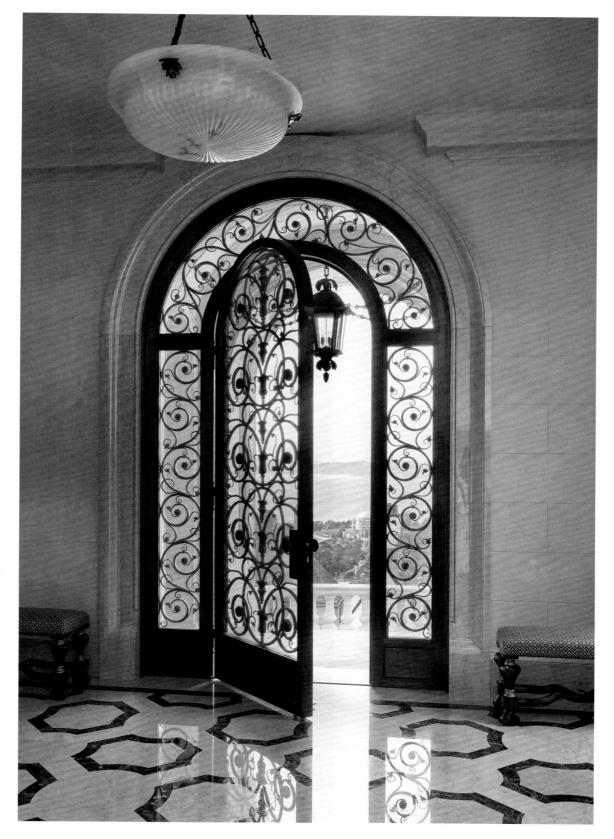

Entrance Hall of an Italian Palazzo

PROJECT CREDITS

URBAN HOMES

A French Hôtel Particulier

Project Architects:
Ed Watkins & Gayan
Hettipola

Interior Designer:
Suzanne Tucker
of Tucker & Marks

Antique French Room:
Galerie Steinitz

Game Room:
Féau Boiseries

Metalwork:
Atelier Saint-Jacques

Decorative Plasterwork:
Foster Reeve

Decorative Finishes:
Philippe Grandvoinet

General Contractor:
Van Acker Construction
Associates Inc.

Watercolor:
Alexander Preudhomme

Photography:
Roger Davies

pp.14, 84-85, 100-101

A Georgian City House

Project Architects:
Heather Hart & Eric Haun

Interior Designer:
Ken Fulk Inc.

General Contractor:
Lencioni Construction

Watercolor:
Lily Xing

Photography:
Jade Studios, San Francisco

pp.15, 80

An Addition to the Lewis G. Morris House

Watercolor:
Alexander Preudhomme

p.16

An Italian Palazzo

Project Architects:
Pierre Guettier
& Paige Mariucci

Interior Designer:
Suzanne Tucker
of Tucker & Marks

Stonemason:
QuarryHouse

Metalwork:
Michael Bondi

Decorative Plasterwork:
Foster Reeve

Decorative Finishes:
Philippe Grandvoinet

General Contractor:
Level 10 Construction

Watercolor:
Andrea Miloslavic

Photography:
Roger Davies

pp.17, 66, 83, 88, 92, 107

A Georgian Townhouse

Project Architect:
Ed Watkins

Interior Designer:
Martha Angus

General Contractor:
Cove Construction

Watercolor:
Brendan Hart

Photography:
Matthew Millman

pp.18-19, 64, 81, 90

A Townhouse in Warsaw

Watercolor:
Alexander Preudhomme

p.20

Section Through a French Townhouse

Project Architects:
Ed Watkins & Paige Mariucci

Interior Designer:
Allison Caccoma

Metalwork:
Michael Bondi

General Contractor:
Forde-Mazzola Associates Inc.

Watercolor:
Alexander Hooyman

p.21

A French City House

Project Architects:
William Wilson
& Steven Sutro

Interior Designer:
Suzanne Tucker
of Tucker & Marks

Metalwork:
Michael Bondi

General Contractor:
Forde-Mazzola Associates Inc.

Watercolor:
Alexander Preudhomme

Photography:
Matthew Milman

pp.22, 82, 89

A Southern-French Hôtel Particulier

Project Architects:
Pierre Guettier
& Rachel Hettipola

Interior Designers:
Jean-Louis Denoit &
Suzanne Kisbye Design

Stonemason:
Omnistone Masonry

General Contractor:
Van Acker Construction
Associates Inc.

Watercolor:
Lily Xing

Photography:
David Hayes

pp.23, 70-71

The Salon Doré at the Legion of Honor in San Francisco

Project Lead:
Martin Chapman, Curator
of European Decorative Arts
at the Fine Arts Museums
of San Francisco

Project Architect:
Bill Hull

Watercolor:
Paul Hayes

p.24-25

SUBURBAN VILLAS

A Southern-French Renaissance Château

Project Architect:
Suzette Smith

Interior Designer:
Karen Yttrup

General Contractor:
Peninsula Custom Homes

Watercolor:
Alexander Preudhomme

Photography:
Akira Kurihara

pp.28, 63, 95

A Louis XVI Pavillon

Project Architect:
Akira Kurihara

Interior Designer:
Diane Chapman Interiors

Front Doors:
Asselin Inc.

General Contractor:
Lencioni Construction

Watercolor:
Brendan Hart

Photography:
Matthew Millman
& Mark Darley

pp.29, 76, 79, 106

An Indo-Doric Palace

Project Architect:
Akira Kurihara

General Contractor:
Vadehra Builders

Watercolor:
Alexander Preudhomme

Photography:
Andrew Skurman

pp.30, 73

A Classical Greek House

Project Architects:
David Buergler, Suzette
Smith & Akira Kurihara

Interior Designer:
Suzanne Tucker
of Tucker & Marks

General Contractor:
Plath & Company

Watercolor:
Brendan Hart

Photography:
Mark Darley

pp.31, 65, 102

A Georgian Cottage

Project Architect:
Kathleen Bost

Interior Designer:
Suzanne Tucker
of Tucker & Marks

General Contractor:
Lencioni Construction

Watercolor:
Lauren Hedge

p.32

A French Pavillon

Project Architect:
Eric Haun

Interior Designer:
Studio Volpe

General Contractor:
Peninsula Custom Homes

Watercolor:
Brendan Hart

Photography:
Matthew Millman

pp.33, 62

An Etruscan Villa

Watercolor:
Alexander Preudhomme

p.34

An Early-American Country House

Project Architects:
David Buergler
 & r. Mark Rushing

General Contractor:
Tincher Construction

Watercolor:
Brendan Hart

Photography:
Mark Darley

pp.35, 77, 103

A Florentine Villa

Watercolor:
Alexander Preudhomme

p.36

A Spanish Colonial Villa

Project Architect:
Akira Kurihara

Interior Designer:
Rush Jenkins & Klaus Baer

General Contractor:
Alftin Construction

Watercolor:
Alexander Preudhomme

p.37

An English Cottage

Project Architect:
Akira Kurihara

Watercolor:
Alexander Preudhomme

p.38

A Hôtel Particulier in India

Project Architects:
Pierre Guettier & Bill Hull

Watercolor:
Darren Yafai
& Alexander Preudhomme

p.39

A Palladian Villa

Watercolor:
Studio of Skurman Architects

p.40

An American Georgian House

Project Architects:
Jeff Eade & Natasha Juliana

General Contractor:
Bridger Construction

Watercolor:
Lauren Hedge
& Brendan Hart

p.41

A Georgian Penthouse Apartment

Project Architect:
Suzette Smith

Interior Designer:
Suzanne Tucker
of Tucker & Marks

General Contractor:
Moroso Construction

Watercolor:
Ashlen Zapara

Photography:
Roger Davies

pp.42, 93, 98-99, 104-105

The Resort at Pelican Hill

Project Architect:
Steven Sutro

Interior Designer:
Darrel Schmidt Design Associates

General Contractors:
Cuesta Construction, Snyder Langston, & Wentz Group

Watercolor:
Brendan Hart

Photography:
Marshall Williams

pp.43, 94, 110

COUNTRY ESTATES

An Anglo-Norman Country House

Project Architects:
Ed Watkins & Roger Farris

Millwork & Doors:
Hull Historical

General Contractor:
Kevin Ralph & Associates

Watercolor:
Brendan Hart

Photography:
Mark Daley

pp.46, 60-61, 72, 96-97

A Tuscan Villa

Project Architects:
Suzette Smith
& Carolina Mendy

Interior Designer:
Suzanne Tucker
of Tucker & Marks

General Contractor:
Forde-Mazzola Associates Inc.

Watercolor:
Darren Yafai
& Alexander Preudhomme

Photography:
Andrew Skurman

pp.47, 86

A Terraced Spanish Villa

Project Architect:
Pierre Guettier

Interior Designer:
Suzanne Tucker
of Tucker & Marks

Cast Stone:
Millbrook Stone Inc.

Plaster Vaulting:
P. J. Ruane

General Contractor:
Peninsula Custom Homes

Watercolor:
Brendan Hart

Photography:
Ed Addeo

pp.48, 67, 74-75, 91

An Italian Lakeside Villa

Project Architects:
Jeff Eade & Eric Haun

Interior Designer:
Brian Murphy Inc.

General Contractor:
Redhorse Constructors

Watercolor:
Alexander Preudhomme

p.49

A Shingle-Style Cottage

Project Architect:
David Buergler

Watercolor:
Alexander Hooyman

p.50

An Equestrian Estate

Project Architects:
Suzette Smith &
Carolina Mendy

General Contractor:
C. A. McKee Construction

Watercolor:
Darrien Yafai, Ashlen Zapara
& Alexander Preudhomme

p.51

A Norman Manoir

Watercolor:
Alexander Preudhomme

p.52

A Palladian Palace

Project Architect:
Akira Kurihara

General Contractor:
Crisci Builders

Watercolor:
Nicole Hull & Lauren Hedge

p.53

An English Country Estate

Project Architects:
Ed Watkins
& Gayan Hettipola

Interior Designer:
Palmer Weiss Interior Design

Watercolor:
Alexander Hooyman

pp.54-55

An American Country Estate

Project Architect:
Ed Watkins
& Gayan Hettipola

Interior Designer:
Monica Cardanini

General Contractor:
Brookstone Builders

Watercolor:
Yueting Zhang

p.56

A French Palace

Project Architects:
Pierre Guettier &
Rachel Hettipola

Watercolor:
Alexander Preudhomme

Photography:
Glen Sherman

pp.57, 68-69, 78

A Spanish Hillside Villa (PHOTOGRAPH ONLY)

Project Architect:
r. Mark Rushing

Interior Designer:
Suzanne Tucker
of Tucker & Marks

General Contractor:
Ryan Associates

Photography:
David Duncan Livingston

p.87

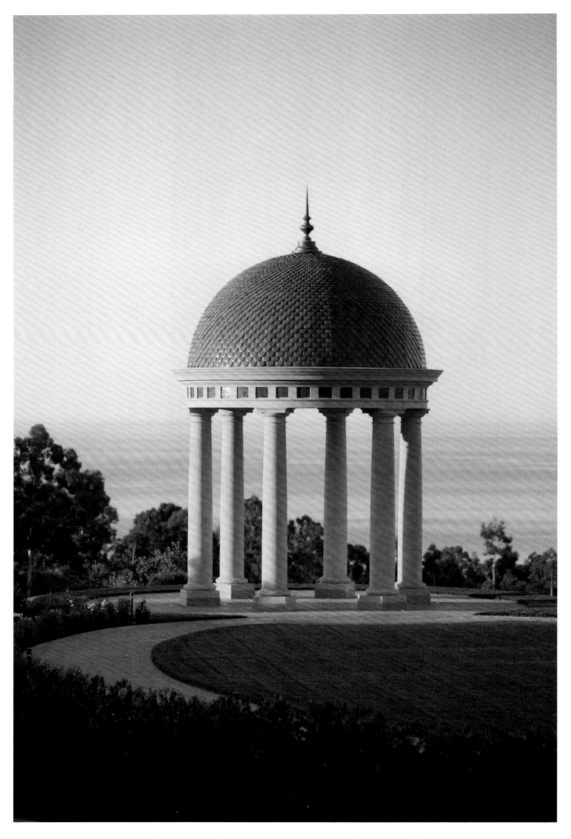

A Monopteral Temple at the Resort at Pelican Hill

ACKNOWLEDGMENTS

Those who had a hand in this book, and in the projects within it are far too numerous to name here. First and foremost, I would like to thank my wife, Francoise Jaudel Skurman, for her loving support, council, and encouragement.

For their countless contributions to the works published here, as well as to the success of Skurman Architects over more than three decades, I would like to acknowledge and thank the many associates and interns of the firm that I have had the pleasure of working with over that time.

These projects could not have been completed without the steadfast guidance and strong leadership of Skurman Architects' studio directors Pierre Guettier and Ed Watkins, as well as former studio directors Suzette Smith, and the late Akira Kurihara.

A significant portion of the firm's work over the years has been designed in close and fruitful collaboration with the interior design firm of Tucker & Marks, lead by Suzanne Tucker—a close friend and treasured colleague.

I would also like to make a special thank you to Martin Chapman—former curator of European decorative arts and sculpture at the Legion of Honor in San Francisco—for facilitating our work on the restoration of the Salon Doré there.

The firm's built work would never have reached the level of quality and beauty it has without the vibrant community of skilled builders, artisans and craftspeople that our projects rely upon wherever we work throughout the world—including and especially those with whom we regularly collaborate in Paris.

It took years of work on the concept that became this book to realize it. That work has been overseen from within our office by Charles Shafer, to whom I am especially grateful.

Alexander Preudhomme has either created or guided the creation of many of the watercolors featured here. He deserves special recognition for his dedication to this work, and for his skilled hand.

I must also express my gratitude to Clive Aslet, Dylan Thomas, and the rest of the staff at Triglyph Books who have been wonderful to work with.

Lastly, I am enormously grateful to each of our clients, for trusting us with the work of creating their homes.

ABOUT THE AUTHOR

Clive Aslet is a visiting professor of Architecture at the University of Cambridge and the publisher of Triglyph Books. For many years he worked at the magazine *Country Life*, where he was editor from 1993 until 2006. Since publishing *The American Country House* with Yale University Press in 1990 he has written widely about American architecture among other subjects.

Clive's titles for Triglyph include *Old Homes, New Life: The resurgence of the British country house*; *Living Tradition: The Architecture and Urbanism of Hugh Petter* and *Sir Edwin Lutyens: Britain's Greatest Architect?*

First published in the United Kingdom in 2025
by Triglyph Books

Triglyph Books
154 Tachbrook Street
London SW1V 2NE

www.triglyphbooks.com
Instagram: @triglyphbooks

Words copyright © 2025 Clive Aslet
Artwork copyright © 2025 Skurman Architects
Copyright © 2025 Triglyph Books

PUBLISHER: **Clive Aslet and Dylan Thomas**
DESIGNER: **Paul Tilby**
PRODUCTION MANAGER: **Kate Turner**
ASSISTANT EDITOR: **Devon Harvey**
COPYEDITOR AND PROOFREADER: **Mike Turner**

All rights reserved. No part of this publication may be reproduced, stored in a retrieval system, or transmitted in any form or by any means, electronic, mechanical, photocopying, recording, or otherwise, without prior consent of the publisher.

British Library Cataloguing-in-Publication Data.

A catalogue record for this book is available from the British Library.

ISBN: 978-1-7397314-6-5

Printed and bound sustainably in China.

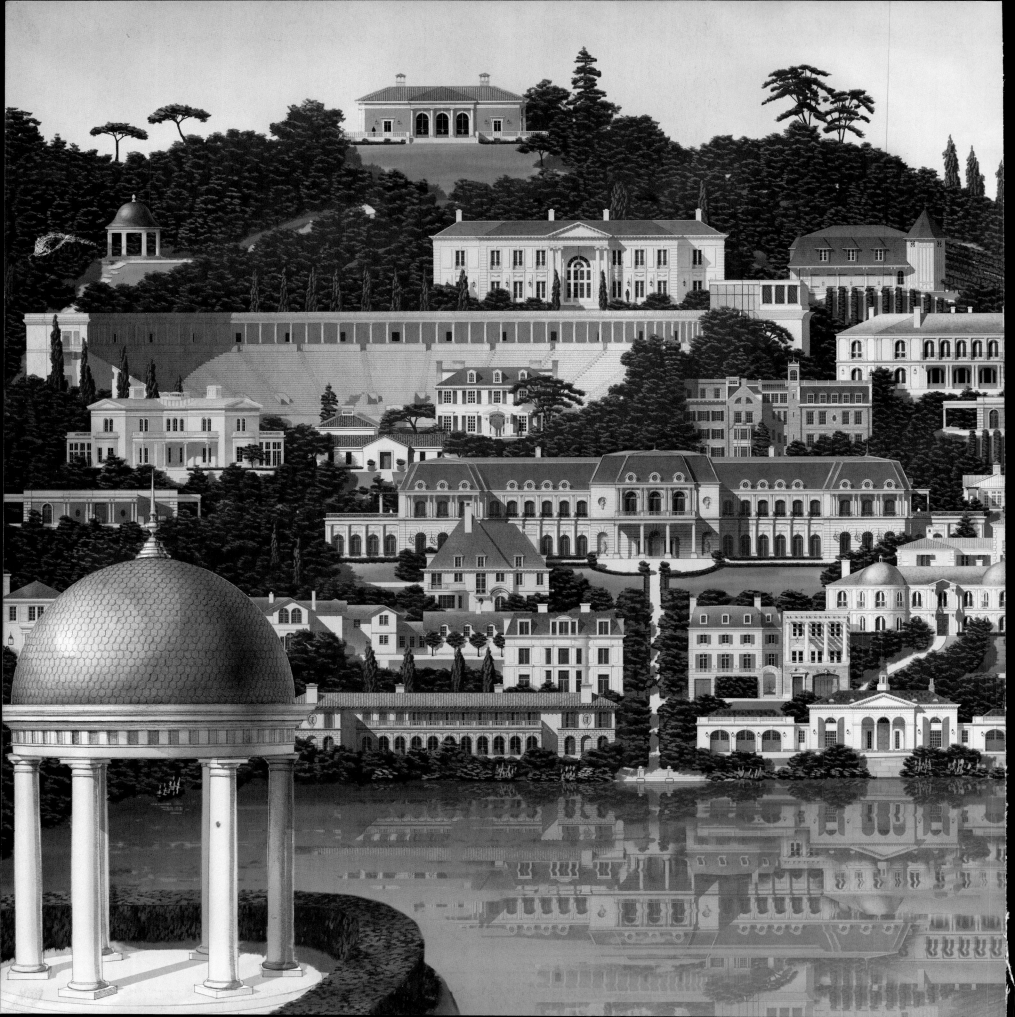